# LETTERS FROM THE
# AVANT-GARDE

## MODERN GRAPHIC DESIGN

# LETTERS FROM THE
# AVANT-GARDE

## MODERN GRAPHIC DESIGN

Ellen Lupton and
Elaine Lustig Cohen

PRINCETON
ARCHITECTURAL   NEW YORK 1996
PRESS

Published by
Princeton Architectural Press
37 East 7th Street
New York, New York 10003
212 995 9620

A Kiosk book

ISBN cloth: 1-56898-084-1
ISBN paper: 1-56898-052-3
First edition
99 98 97 96    4 3 2 1

Printed and bound in the United States

Cataloging-in-Publication data for this title is
available at the Library of Congress.

For a free catalog of other books
published by Princeton Architectural Press,
call toll free 1 800 722 6675

# CONTENTS

Many people contributed their talent and knowledge to the making of this book. Michael Sheehe was a continuing source of information and insight as we worked to tell a story about the avant-garde through the medium of the letterhead. Eva Christina Kraus brought her understanding of European languages and cultures as well as her strong gift for design. Jennifer Ehrenberg generously shared research that she had conducted at The Getty Center for the History of Art and the Humanities, and she contributed important entries to the plate section of this book. Paul Makovsky was involved with the project at its inception; his initial research on letterhead design provided us with a sturdy foundation. ■ The research for this

**ACKNOWLEDGMENTS**

book parallels the exhibition *The Avant-Garde Letterhead,* organized by Cooper-Hewitt, National Design Museum, Smithsonian Institution, and presented at the American Institute of Graphic Arts in New York City, March 13–May 8, 1996. Many people at the Museum worked on the exhibition, including Nancy Aakre, Gail Davidson, Linda Dunne, John Fell, Lucy Fellowes, Samantha Finch, Pamela Haylock, Laura James, Steven Langehough, Barbara Livenstein, Liz Marcus, Christine McKee, Gillian Moss, Brad Nugent, Dianne H. Pilgrim, John Randall, Cordelia Rose, Sheri Sandler, Larry Silver, Marilyn Symmes, Stephen Van Dyk, Susan Yelavich, and Egle Zygas. At the AIGA, Rick Grefé and Moira Cullen were enthusiastic collaborators. ■ The exhibition was sponsored by Crane & Company; we thank Geraldine Winters and James Alexander at Crane for their advocacy and advice. ■ The letterheads presented in this book come primarily from the collection of Elaine Lustig Cohen. We supplemented this material with pieces from several important sources. We thank Hans Berndt, Bruno Monguzzi, Michel Seuphor, Michael Sheehe, The Getty Center, Masawa Homes' Bauhaus Collection, Museum für Gestaltung, Basel, and Cooper-Hewitt, National Design Museum. ■ The staff of Princeton Architectural Press responded creatively to the editorial and production issues raised by the book; we enjoyed working with Mark Lamster and Kevin Lippert. ■ Many colleagues and friends shared their support and expertise. We thank Martin Fox, James Fraser, Rudolph de Harak, Steven Heller, Anthony Inciong, Caitlin James, Maud Lavin, Luce Marinetti, Philip Meggs, Abbott Miller, and Jennifer Tobias. E. L. and E. L. C.

As a designer, I have always been fascinated by the letterhead. This small-scale object is one of the most challenging design problems. It must be personal and strong, using minimal means to reflect the spirit of an individual or a company. It is a direct encounter with a piece of paper that is usually more sensual and luxurious than the stock for other printed pieces. ■ The letterheads documented in this book come from a collection I began building with Arthur A. Cohen in the early 1970s. As proprietors of Ex Libris, a bookstore specializing in avant-garde printed matter, we often acquired letters and letterheads as part of an artist's archive. Many of the pieces in my collection come from the archives of Jean Badovici, Herbert Bayer, and Piet Zwart, who communicated prolifically with the international avant-garde. In examining these archives, one became privileged to their world through their notes, letters, and ephemera. As you pulled a letter from an envelope, you could smell the past. ■ At Ex Libris we offered the letterheads in our catalogues along with books and other works on paper, but they rarely sold. Greedily, I kept them for myself. Perhaps stationery was considered too commonplace by other collectors. ■ Many of these letterheads were created by painters who were also designers. As a painter/designer myself, I was excited by the fact that artists in the 1920s were also producing remarkable typographic work. El Lissitzky, Laszlo Moholy-Nagy, and Kurt Schwitters incorporated design into their careers. There is no question they did this for financial reasons, but they did it with the same intensity they brought to their art. Literary movements like Dada and Futurism explored the link between printing and poetry. Language was the primary medium for Tristan Tzara and F. T. Marinetti, and words were their advertisements. ■ This collection of European letterheads augmented my personal archive of stationery designed by Alvin Lustig. Alvin's letterheads from the 1930s and 40s are among his most innovative work, and are rarely studied or reproduced. This book illustrates his relationship with European design theory and with America's own network of progressive designers. ■ In contrast to today's instant faxes and e-mail, this sheet of paper—the letterhead—signed, folded, stamped, and posted, allows for reflection and intimacy.

# NET WORKS

## INTERNATIONAL AVANT-GARDE

The diagram at right indicates some of the links connecting avant-garde movements in the early twentieth century. Ideas flowed between Dada and Constructivism, De Stijl and the Bauhaus, Moscow and Berlin. Artists and designers were nourished by an international network of communications, whose infrastructure consisted of magazines, public lectures, personal contacts, and written correspondence.

## DADA + SURREALISM

The Dada movement was founded by TRISTAN TZARA in Zurich in 1916. Dada poets and artists used nonsense verse, found objects, and public performance to challenge conventional notions of art. TZARA's poetry borrowed visual and verbal idioms from advertising. Dada quickly became an international movement in art and literature with diverse geographic centers.

In 1924, ANDRÉ BRETON established Surrealism in Paris. He rejected Dada's typographic acrobatics in favor of the vernacular conventions of academic publishing.

**BUREAU DE RECHERCHES SURRÉALISTES**
15, Rue de Grenelle, PARIS (7ᵉ)   SECRÉTARIAT GÉNÉRAL : **FRANCIS GÉRARD**
*ORGANE MENSUEL :*

## La Révolution Surréaliste

Although Surrealism did not evolve a distinctive typographic style, Surrealist painting had a broad influence on advertising and design in Europe and the U. S.

## FUTURISM

F. T. MARINETTI founded Futurism in 1909. He lectured across Europe during the 1910s.

MARINETTI distributed pamphlets and manifestos from his office in Milan, propelling Futurism to international fame.

**Mouvement Futuriste**
dirigé par **F. T. MARINETTI**
— MILAN - Corso Venezia, 61 —

LISSITZKY's exhibition designs, which used dramatic photomurals to promote the achievements of the Soviet state, influenced exhibitions created for the Fascist government in Italy in the 1930s.

The Italian Futurist FORTUNATO DEPERO worked in New York from 1928 through 1930, and again from 1947 to 1949. He brought a popular interpretation of Futurism to ads and magazines.

**MODERNISM IN AMERICA** | Many artists and intellectuals travelled across the Atlantic Ocean to work in the United States. Some, like DEPERO, returned home to finish their careers.

| DUTCH MODERNISM | SCHWITTERS + THE RING | BAUHAUS | CONSTRUCTIVISM |
| --- | --- | --- | --- |

Futurist poetry influenced VAN DOESBURG, SCHWITTERS, and other Dadaists, who engaged the physical qualities of type. In 1910 and 1914, MARINETTI lectured in St. Petersburg.

THEO VAN DOESBURG began publishing *De Stijl* in Holland in 1917, a magazine with a small but international distribution. VILMOS HUSZAR designed the logo.

De Stijl's language of right angles and primary colors embodied a theory of infinite space.

Under a pseudonym VAN DOESBURG published Dada poetry. He became a friend of SCHWITTERS in 1921.

## DE STIJL

LISSITZKY lectured in Holland in 1923, an event that encouraged VAN DOESBURG to explore Constructivism. Work by LISSITZKY was published in *De Stijl*.

## NWG

Members of the *ring* in Holland included PIET ZWART and PAUL SCHUITEMA.

---

In Hanover in 1919 KURT SCHWITTERS adopted the word *Merz* as a kind of brand name for his Dada poetry and collages.

LISSITZKY inspired SCHWITTERS to experiment with Constructivist typography. They collaborated on a special issue of SCHWITTERS'S magazine *Merz* in 1924.

SCHWITTERS established Merz Werbezentrale in 1923, an agency that designed advertisements and stationery for clients in Hanover. He founded the *ring "neue werbegestalter"* (circle of new advertising designers) in 1928, an international consortium of designers working with Constructivist ideas. Designers belonging to the *ring* were located across Germany, from JAN TSCHICHOLD in Munich to WALTER DEXEL in Jena.

---

The Bauhaus was founded in 1919. WALTER GROPIUS was its first director.

VAN DOESBURG went to Weimar in 1921, where he staged informal lectures.

LISSITZKY made Berlin his European outpost. His work with avant-garde magazines and commercial clients influenced the Bauhaus.

In 1923 MOHOLY-NAGY went to teach design and photography at the Bauhaus. Rational methodologies reshaped the school after 1923, as Constructivism supplanted approaches to design based in craft traditions and Expressionism. In 1925 the Bauhaus moved to Dessau; the school was closed by the state in 1933.

---

EL LISSITZKY, ALEXANDER RODCHENKO, and others founded the Constructivist movement around 1919. They drew on the abstract painting of KASIMIR MALEVICH and the concrete typography of Futurism and Dada to build a new public language. LISSITZKY travelled extensively outside the USSR during the 1920s.

Constructivist magazines emerged in Poland, Czechoslovakia, and elsewhere in Eastern Europe during the 1920s. The Hungarian artist and designer LASZLO MOHOLY-NAGY contributed to *MA*, a Hungarian journal published in Vienna.

In Warsaw, HENRYK BERLEWI founded the Constructivist ad agency Reklama Mechano in 1924. In Prague, LADISLAV SUTNAR designed ads, exhibitions, and stationery during the 1920s and 30s.

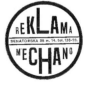

Others moved permanently to the U.S., including the Bauhaus designers GROPIUS, BAYER, and MOHOLY-NAGY, and the Czechoslovakian Constructivist SUTNAR.

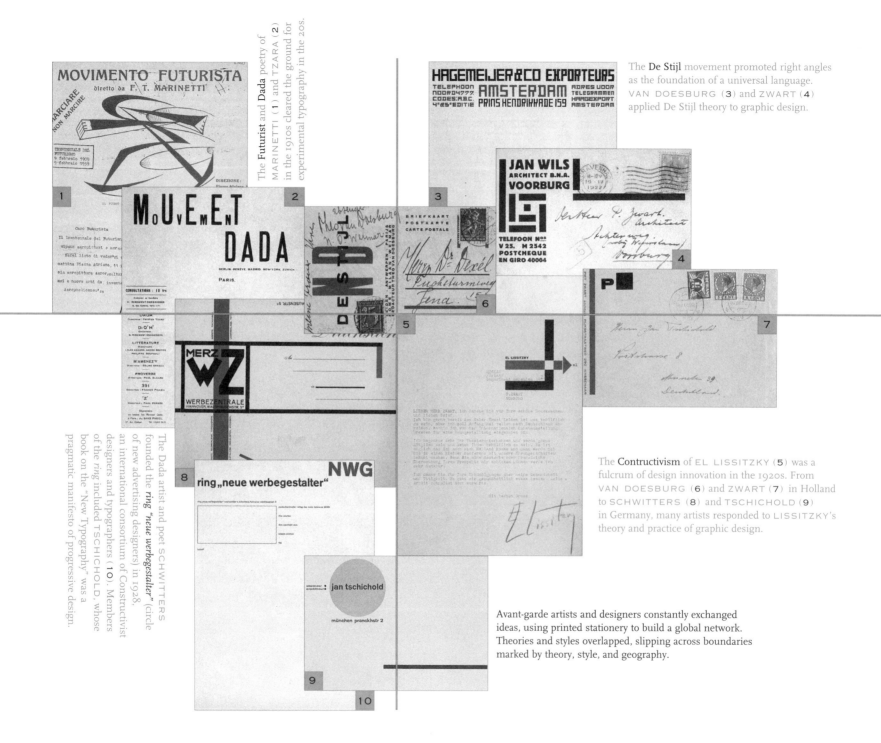

The Futurist and Dada poetry of MARINETTI (1) and TZARA (2) in the 1910s cleared the ground for experimental typography in the 20s.

The **De Stijl** movement promoted right angles as the foundation of a universal language. VAN DOESBURG (3) and ZWART (4) applied De Stijl theory to graphic design.

The Dada artist and poet SCHWITTERS founded the *ring "neue werbegestalter"* (circle of new advertising designers) in 1928, an international consortium of Constructivist designers and typographers. Members of the *ring* included TSCHICHOLD (10), whose book on the "New Typography" was a pragmatic manifesto of progressive design.

The **Contructivism** of EL LISSITZKY (5) was a fulcrum of design innovation in the 1920s. From VAN DOESBURG (6) and ZWART (7) in Holland to SCHWITTERS (8) and TSCHICHOLD (9) in Germany, many artists responded to LISSITZKY's theory and practice of graphic design.

Avant-garde artists and designers constantly exchanged ideas, using printed stationery to build a global network. Theories and styles overlapped, slipping across boundaries marked by theory, style, and geography.

A global network of avant-garde movements flourished during the first half of the twentieth century, connecting artists and designers across Europe and the United States. Written correspondence, presented on dramatically designed stationery, was a vital part of the infrastructure of this international community. Artists and designers translated concepts from painting, poetry, and architecture onto the commercial format of the letterhead, creating, in effect, "corporate identities" for modernism. Stationery for Futurism, Dada, De Stijl, the Bauhaus, and other groups and institutions served as typographic manifestos for the avant-garde.

# NET WORKS

**ELLEN LUPTON**

Some of these works drew on the normative conventions of commercial stationery—often with a flash of irony—while others reflected new concepts of typographic rationality. ■ From Moscow to Amsterdam, numerous artists turned to graphic design as a legitimate avant-garde practice in the years around 1920. Trained as an architect, EL LISSITZKY embraced graphic design for its intellectual challenges and social possibilities. The Dutch painter THEO VAN DOESBURG used typography to promote the de Stijl aesthetic as a universal visual language that would link cultures across the globe with its transcendental grid. These designers created letterheads to publicize their own work; they also produced advertising, stationery, and other graphics for commercial clients. ■ Such forays into the domain of graphic design by modern painters and poets were not just money-making distractions from the serious matter of art but reflected the avant-garde ambition to merge art into life.[1] Printed media enabled artists to use mass communications not only as the raw material for personal visions, as in Cubist collage, but as vehicles for public address that artists could directly mobilize. Rather than borrow and quote popular culture, they could help to create it. ■ While radio, film, and industrial architecture were grand and heady symbols of the modern age, few artists were able to complete substantial

projects in these capital-intensive realms. In contrast, printing was grounded in established, accessible technologies. Many artists and architects were able to create their own vehicles for public communication through letterpress typography and photomechanical reproduction. ■ Working in Moscow and Berlin in the 1920s, LISSITZKY was fascinated with dematerialized modes of communication. In 1926 he described letter-writing as a medium on the verge of obsolescence, ready to be replaced by telephone and radio:

> Correspondence grows, the number of letters increases, the amount of paper written on and material used up swells, then the telephone call relieves the strain. Then comes further growth of the communications network....then radio eases the burden. The amount of material used is decreasing, we are dematerializing, cumbersome masses of material are being supplanted by released energies.[2]

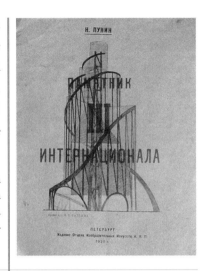

Although LISSITZKY denigrated paper as a dying medium, his global influence derived from his inventive use of printing technologies. ■ Avant-garde artists and designers created visual identities for themselves in response to the compelling commercial images that were flooding modern culture. Nineteenth-century stationery typically carried a likeness of a company's factory, employed as a prestigious icon of its physical assets. The growth of advertising and packaging stimulated the design of logos, trademarks, brand names, and the use of specific colors and typefaces to symbolize a product. ■ The ancestry of the modern letterhead lies in the growth of formal written correspondence and the rise of printed trade cards and billheads. A commercially operated network of mail routes spread across Central Europe by the early sixteenth century. A papal bull or king's proclamation was a mode of public address that was written in the form of a letter and authorized by an official seal. Letter-writing was an early way to convey information between one town and the next. The "newsletter" is the origin of the printed newspaper, whose banner-like masthead resembles the design across the head of a letter. Business stationery engraved with a seal or symbol became common during the eighteenth century.[3] ■ In Europe and the U.S., letterheads in the nineteenth century typically were printed from metal plates engraved with finely detailed lettering, ornaments, and images.

Vladmir Tatlin exhibited his model for the *Monument to the Third International* in St. Petersburg in 1920. Although Tatlin's multi-media megastructure was never built, a brochure was published in 1920 that circulated throughout Europe. Tatlin's tower thus reached a broad community of architects and designers. In the end, its most effective medium was the printed page.

The work of the William T. Manning Company demonstrates the strength and longevity of the printer's vernacular. Founded in 1925 in Waterbury, Connecticut, the firm specialized in photogravure, a technique that can reproduce tiny, exquisitely detailed photographs on soft bond paper. Samples produced between 1940 and 1965 reveal that the company worked within a narrow range of permissable design solutions. Countless factories and bank facades sit quietly across the top of each letterhead, labelled with discrete lines of type. The sketches above show the care taken by in-house designer Joel Anderson to explore subtle variations within a rigidly proscribed formula. Collection Cooper-Hewitt, National Design Museum, Smithsonian Institution, Gift of Ed Manning

Printers could create custom designs for clients, or they could assemble ready-made alphabets and illustrations presented in catalogues. Photomechanical processes allowed printers to transfer stock material to the engraving plate. In a typical design, a mass of words and pictures ran across the top of the page, woven together with ornaments. ■ Beginning in the 1920s, freelance design consultants began devising instructions for printers; designers served to mediate between clients and production houses. Letterheads became economically important vehicles for the new profession. Letterhead designs that left behind the printer's vernacular in favor of asymmetrical compositions of simple, direct symbols and typefaces were commonplace by the 1930s, revealing the impact of avant-garde design on the commercial mainstream.[4] ■ Today, printers of stationery continue to offer design services directly to their customers. From the centered lines of script on a traditional wedding invitation to the blocks of square capitals occupying the four corners of a standard business card, the conventional grammar of stationery has maintained its authority alongside the individualistic, deliberately inventive strategies offered by independent design consultants. ■ The authoritative printer's vernacular was the visual context in which avant-garde artists and designers began producing letterheads to promote their own enterprises. One of the first was F. T. MARINETTI. As leader of

ALL CALLERS
WELCOME

TELEPHONE
BUTTERFIELD 8

YOUR NAME HERE

1171 PARK AVE

NEW YORK, NY

the Futurist movement for thirty-five years, he produced numerous letterheads and postcards. The Dada writer TRISTAN TZARA used typographic devices routinely found in commercial advertising, such as mixed fonts and shifting scales of type, in his poetry. He interspersed large and small capitals to create a letterhead for the *Mouvement Dada* around 1918. ■ KURT SCHWITTERS, best known today for his work as an artist and poet, established a successful advertising agency in 1923. While his Dada collages dredged the irrational side of printed media by salvaging tickets, candy wrappers, and other bits of discarded ephemera, his commercial typography embraced ideals of objectivity and direct communication. ■ SCHWITTERS's decision to begin working in the field of graphic design reflected the profound influence of EL LISSITZKY in Germany and Holland. In his Constructivist books and posters, LISSITZKY arranged sans serif letterforms and geometric rules and ornaments in dynamic compositions that shuffled the meanings of familiar forms. He sought to build a new public language out of the aesthetic experiments of Suprematist painting and Dada and Futurist poetry. While those experiments had engaged the internal discourse of the fine arts, Constructivism turned the focus of these aesthetic ideas outward. The Constructivists used publishing, advertising, and

exhibitions as platforms for addressing international audiences. In the language of vision that LISSITZKY aimed to forge, typographic convention would give way to pictorial abstraction, provincial dialects would yield to a global order, and phonetic writing would be illuminated by photographs and universal symbols. ■ LISSITZKY travelled extensively in Western Europe during the 1920s, where he became widely known through his essays, lectures, and personal contacts. Working in Berlin, he met KURT SCHWITTERS, THEO VAN DOESBURG, RAOUL HAUSMANN, LASZLO MOHOLY-NAGY, MIES VAN DER ROHE, and other members of the avant-garde.[5] ■ JAN TSCHICHOLD formalized Constructivist ideas into a coherent design methodology in his book *The New Typography*, published in 1928. Recasting the designer in the garb of the engineer, TSCHICHOLD attacked the centered arrangements of classical typography and the florid individualism of Art Nouveau and Jugendstil in favor of asymmetrical layouts, uniform page sizes, and the orderly presentation of text. The phrase "New Typography" became the banner for a movement that linked designers in Germany, Holland, Switzerland, Poland, Hungary, and the Soviet Union. TSCHICHOLD illustrated his theories with examples of work by an international cast of contemporary artists and designers. He listed their addresses at the back of his book, enabling interested readers to make personal contact through the mail. As Robin Kinross has pointed out, TSCHICHOLD was the only figure in this roster of vanguard luminaries who was formally trained as a typographer—the others came to the printed page from painting, poetry, or architecture.[6] ■ TSCHICHOLD exercised his acute sensitivity to typographic detail in a chapter of *The New Typography* devoted to business forms. Presenting the letterhead as a structured field activated by data rather than a decorative frame surrounding an empty center, he wrote, "In general, the typography of the old letterheads took no notice of the fact that the letter as received would be written, signed, and folded. Only when it is a completed whole can it look beautiful!" (p.117). TSCHICHOLD thus considered not only the design of the letter's printed elements but the way the typescript would be positioned on the page. A generous left-hand margin would leave space for hole-punching and would form a strong axis against which the text of the letter would align; letters should be typed solid, with no lines between paragraphs. ■ The Deutsche Industrie Normen (DIN) established uniform page sizes in the early 1920s. The A4 format (210 x 297 mm) set the standard for the size of letterheads in Germany and other countries that used the metric system. TSCHICHOLD was familiar with the ideas of WALTER PORTSMANN, a leading

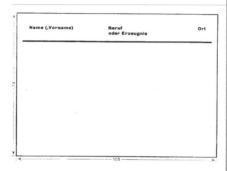

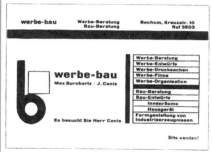

Jan Tschichold's 1928 book *The New Typography* features examples of avant-garde design by many of the author's contemporaries. The book includes a detailed chapter on the design of business stationery, including letterheads, envelopes, postcards, and business cards. The diagram above left shows the proper organization of content on a business card: the name, address, and phone number should appear across the top, with the space below reserved for information about the business. He reproduced several examples that fit his theoretical model, including the business card above right, designed by Max Burchartz and Johannis Canis.

reformer of office work and an architect of DIN, who viewed the business letter not as a one-time link between two individuals but as permanent hardware in the mechanics of bureaucracy.[7] As TSCHICHOLD wrote in *The New Typography*, a letter must be easy to read, easy to file, and easy to retrieve: "Thus the letter becomes part of a multiplicity, i.e. a correspondence. Without order, such a multiplicity becomes unmanageable" (p.112). TSCHICHOLD diffused the explosive potential of Constructivist abstraction with an eye for the refined details of the printed page. ■ A similarly rational approach informed the work of HERBERT BAYER at the Bauhaus, MAX BURCHARTZ in Bochum, and KURT SCHWITTERS in Hanover. SCHWITTERS, applying the New Typography to a large institutional commission, designed stationery and business forms for the Hanover Town Council beginning in 1929. Hanover's municipal government, forced to dramatically expand its social services under the Weimar Republic, had begun adopting standard page sizes and a looseleaf filing system. To bring typographic order to the city's flow of paper, SCHWITTERS implemented asymmetrical layouts, consistent typographic hierarchies, and the sans serif typeface Futura, a modernist antidote to the blackletter Fraktur favored by cultural conservatives in Germany.[8] ■ In contrast to the rational systems orchestrated by TSCHICHOLD and others, PIET ZWART's work in Holland tapped a powerful impulse for play. ZWART's initial typographic projects, consisting of logos built with perpendicular elements, applied De Stijl theories in a programmatic way to the construction of symbols. After EL LISSITZKY's lectures in Holland in 1923, ZWART began assembling colorful, open compositions that freely mixed letters and typographic rules in patterns ordered by intuition as well as logic. ZWART's letterheads of the later 1920s exposed Constructivism's roots in the disruptive experiments of Futurism and Dada. ■ The New Typography found its way across the Atlantic in the 1930s, packed up in the suitcases and psyches of European emigrés. Avant-garde design principles fueled a second wave of modernism in the U.S., led by ALVIN LUSTIG, LESTER BEALL and others. Like their European progenitors, these designers built a community of like-minded practitioners that spanned the continent. While the New Typography was elaborated in Switzerland and Germany into a clean, coherent system during this period, American designers preferred to combine willful, painterly gestures with a sense of humor informed by the commercial spirit of advertising. ■ Modernism's formal language is no longer viewed as a universal code. Instead, it is seen as historically bound to the specific cultures of the avant-garde. Unconstrained by geography, these cultures flowed across an international network of communications, whose infrastructure ranged from congresses and exhibitions to magazines and letterheads. While the technologies of such networks have grown more complex, their function remains similar today: to forge links among dispersed individuals, enabling them to share ideas and construct identities.

1 Over the past decade several art historians have acknowledged the signficance of graphic design to avant-garde theory and practice. On Dada and Futurist poetry, see Johanna Drucker, *The Visible Word: Experimental Typography and Modern Art, 1909–1923* (Chicago: University of Chicago Press, 1994). On graphic design in Germany in the 1920s, see Maud Lavin, "Photomontage, Mass Culture, and Modernity: Utopianism in the Circle of New Advertising Designers," *Montage and Modern Life, 1919–1942* (Cambridge: MIT Press, 1992), 37–59. On the importance of photomontage and exhibition design to Constructivism, see Benjamin H.D. Buchloh, "From Faktura to Factography," *October* 30 (Fall 1984): 82–117.

2 *El Lissitzky: Life, Letters, Texts,* ed. Sophie Lissitzky-Küppers (London: Thames and Hudson, 1967).
3 Ernst Lehner, *The Letterhead: History and Progress* (New York: Museum Books, 1955). For an excellent survey of the avant-garde letterhead, see Jennifer Ehrenberg, "Letters from the Front," *Print* 49, 1 (1995): 70-78, 115-116.
4 The assimilation of avant-garde theory into the commercial mainstream can be seen in trade articles such as Anthony W. Bell, "Take a Letter...A Random Note or Two on Letterhead Design," *Art and Industry* 27, 169 (October: 1939): 148–155.
5 L. Leering-van Moorsel, "The Typography of El Lissitzky," *Journal of Typographic Research* 2, 4 (October 1968): 323–340.

6 *The New Typography*, first published in 1928, has been reissued in English, translated by Ruari McClean with an introduction by Robin Kinross (Berkeley: University of California Press, 1995).
7 The standardization of paper sizes was discussed in two trade articles: Dr. Fritz Wlach, "Der Vordruck (Das Formular)," and Dr. [Walter] Portsmann, "Kunst und Normung," both in *Gebrauchsgraphik* 9 (1925): 19-24. Paul Renner discusses DIN and stationery design in *Die Kunst der Typographie* (Berlin: Frenzel & Engelbrecher Gebrauchsgrafik, 1939).
8 Werner Heine, "'Futura' without a Future: Kurt Schwitters' Typography for Hanover Town Council, 1929–1934," *Journal of Design History* 7, 2 (1994): 127–139.

## A NOTE ON TECHNOLOGY

The letterheads and other ephemera reproduced on the plates that follow are from the collection of ELAINE LUSTIG COHEN unless otherwise noted.

Captions written by JENNIFER EHRENBERG are signed J. E.

Captions written by EVA CHRISTINA KRAUS are signed E. C. K.

All other entries are written by ELLEN LUPTON.

Most of the letterheads shown in this book were produced via letterpress, the technique originated by Gutenberg for printing books in the 1400s. Letterpress is a relief process in which individual pieces of wood or lead, each bearing a raised character, are locked together on a flat bed. The type is then inked and pressed against a sheet of paper. Letterpress printing can be recognized by the "bite" left by the type on the surface of the page, often visible on the back.

In the early twentieth century, letterpress was thus a familiar, time-tested technique. Several innovations, however, had begun to transform letterpress printing, making it quite different from the limited medium it had been since the Renaissance. By 1880, a line illustration drawn on paper could be photomechanically engraved and then printed in combination with metal type on one sheet of paper.

The halftone process was introduced in the 1880s. This technique translated the continuous-tone photograph into a pattern of tiny dots, enabling type and photos to be printed simultaneously. The halftone process ushered in the age of photojournalism.

Offset lithography was introduced at the end of the nineteenth century. In this technique, a metal plate is sensitized so that the parts of it that are exposed to light accept ink and resist water. The resulting print is completely flat, lacking the indentations created in the letterpress process.

Most of the magazines, stationery, and other ephemera produced within the avant-garde discourse were printed with letterpress equipment, which was more economical for short-run printing than offset lithography. One of the innovations of the "New Typography" was to use the existing elements of the printer's typecase in innovative ways. Designers treated the letters, rules, and ornaments that were on hand in a standard print shop as the basis of an abstract language.

While some designers made a philosophical point of using only such typographic elements in their letterhead designs, others employed photomechanically reproduced logos, symbols, drawings, and even photographs. Designers could also reproduce hand-lettering via letterpress by having line engravings made from their original drawings. The technology of letterpress could thus be interpreted in a variety of ways. It could be treated as a rigorously limited grid of possibilities, or as a flexible medium capable of interfacing with a range of other methods.

# FUTURISM

BIBLIOGRAPHY

Drucker, Johanna. *The Visible Word: Experimental Typography and Modern Art, 1909-1923* (Chicago: University of Chicago Press, 1994).

*Marinetti: Selected Writings*. Ed. R. W. Flint (New York: Farrar, Straus, & Giroux, 1972).

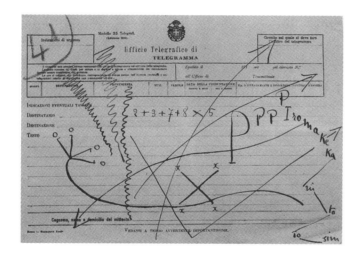

*Telegram 41*
F. T. MARINETTI (1876–1944)
Poem, handwritten on printed form
Italy (Milan), 1914/15
Private collection
■ Marinetti replaced conventional syntax and vocabulary with mathematical symbols and repeated letters.

Futurism was launched in 1909 when F. T. MARINETTI issued a manifesto in the popular Paris newspaper *Figaro*. Born as a media event, Futurism engaged the technologies of communication as both subject matter and means of address. The movement, which peaked between 1914 and 1919, originated in the realm of poetry, but soon expanded to include painting, architecture, and commercial design. A skilled promoter, MARINETTI issued numerous letterheads from his headquarters in Milan and Rome. Painters, poets, architects, and designers responded to MARINETTI's fervent demand to create a movement in Italian art suited to the dynamism of the twentieth century, including GIACOMO BALLA, FRANCESCO CANGUILLO, FORTUNATO DEPERO, and FERNANDO CERVELLI. ■ MARINETTI was indebted to the French Symbolist poetry of MALLARMÉ, who had experimented with page composition and mixed typography at the close of the nineteenth century. MARINETTI rejected MALLARMÉ's fascination with interior psychology and embraced the bluntly material imagery of war, machines, and a sexuality stripped of romance. He aimed to rid language of its metaphoric pretensions and leave it in a state of raw objectivity. ■ Brandishing the phrase "wireless imagination" as a Futurist motto, MARINETTI saw the telegraph, telephone, and radio as the characteristic media of modernity. Several pieces of Futurist stationery were derived from standard telegraph forms, and MARINETTI imitated the telegram in his famous poem "Letter from a Pretty Woman to an Old-Fashioned Man," published in 1914, in which a young woman presents her lover with an "invoice" in exchange for erotic intimacy. ■ Although MARINETTI revered electronic communication, his most influential work explored the physical tactility—not the wireless disembodiment—of writing. The Futurist battle against poetic convention cleared the ground for the "New Typography" of the 1920s, which replaced the nationalist impulses of MARINETTI, CERVELLI and others with the search for a universal language.

*Lettera-Futurista*
FRANCESCO CANGUILLO (1884–1977)
Letterhead
Italy (Milan)
Letter dated 1915
Letterpress
■ This letterhead is based on a standard telegraph form, customized to fit the Futurist agenda. The page is marked off into spaces, labelled with the subjects Futurism, war, pleasures, news, women, travels, and greetings. The final space is reserved for the "total," suggesting that the list of thoughts diagrammed by the letterhead could be mathematically calculated.  E. C. K.

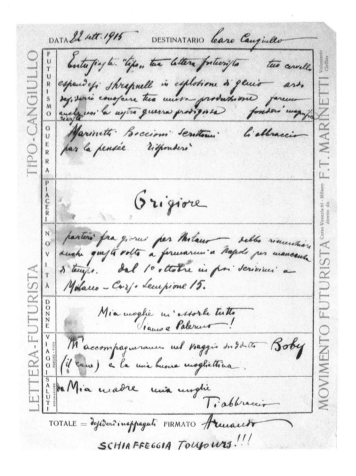

*Movimento Futurista*
FRANCESCO CANGUILLO
Postcard
Italy (Rome), 1915
Letterpress
■ Like the letterhead at left, this postcard employs a telegraph form whose "blanks" have been altered to reflect the Futurist sensibility. The space for the closing greeting is marked *"saluti o insulti,"* salutation or insult. The colors of the Italian flag invoke the movement's nationalist orientation.

*Mouvement Futuriste*
F. T. MARINETTI (1876–1944)
Letterhead
Italy (Milan)
Letterpress
■ The title and address is printed in French. Marinetti, who was immersed in the international art world, had strong ties with French art and poetry.

*Movimento Futurista*
F. T. MARINETTI
Drawing by
GIACOMO BALLA (1871–1958)
Letterhead
Italy (Rome)
Letter dated 1939
Letterpress
■ Marinetti used this drawing by Balla, based on Boccioni's sculpture *Fist of Boccioni*, on his letterhead as early as 1918. The slogan *"Marciare non marcire"* means "To march not to rot." The drawing was created in 1916 following the death of Boccioni.

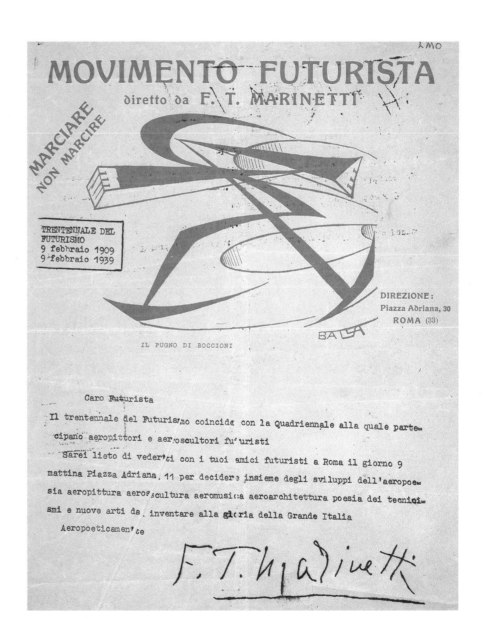

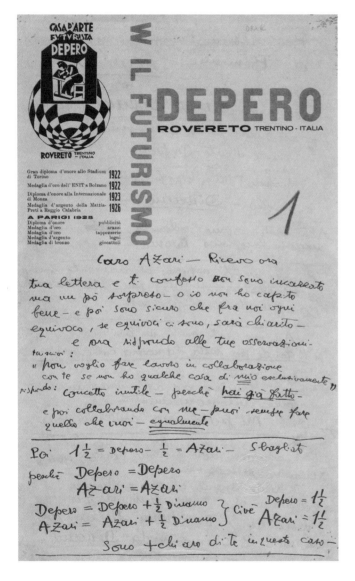

*Mazzotti*
BRUNO MUNARI (b. 1907)
Letterhead
Italy
Letter dated 1934
Letterpress
■ Munari's illustration reflects the Dada and Surrealist fascination with absurd, anthropomorphic machines.

*Depero*
FORTUNATO DEPERO (1892–1960)
Letterhead
Italy (Trentino), c. 1927
Letterpress
Collection Getty Center for the History of Art and the Humanities, Santa Monica
■ Each of the numerous letterheads, fliers, and postcards Depero created to advertise his *Casa d'Arte Futurista*, established in 1919, listed not only all of his services, but also the medals and awards he had won for the design of advertising, tapestries, toys, woodcuts, and other products. To the left of the large type, which reads "Long Live Futurism," sits a figure stylistically similar to others in Depero's graphic work. In this five-page letter to painter/writer Fedele Azari, Depero addressed a misunderstanding he and Azari had over working together, and he offers a mathematical solution to future collaborative efforts. J. E.

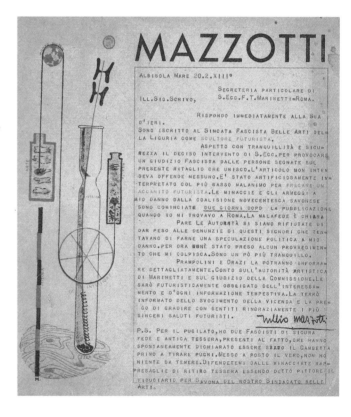

Set in a pyramid on the back of the letterhead is a quote from Mussolini: "We are a young people who wish and need to create, and we refuse to be a union of innkeepers and museum custodians. Our artistic past is admirable, but as far as I am concerned, I will have set foot in a museum twice at the very most!" J. E.

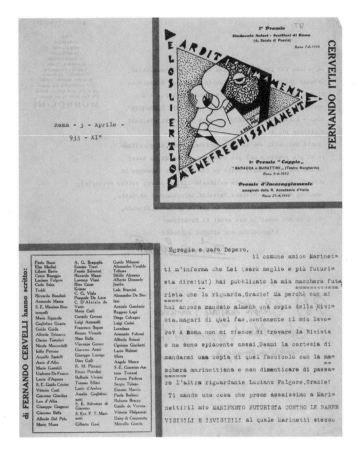

*Fernando Cervelli*
ANONYMOUS
Letterhead, front and back
Italy (Rome)
Letterpress
Letter dated 1932
Collection Getty Center for the History of Art and the Humanities, Santa Monica
■ The illustration is surrounded by the words "Most Daringly/Not Giving a Good Goddamn/Beyond the Sun." The box of endorsements in the lower left lists people said to have written about Cervelli.

# DADA + SURREALISM

The word "Dada" was invented in Zurich in 1916 by the Romanian poet TRISTAN TZARA. This abstract and infantile utterance became an international slogan whose currency spread, within months of its birth, to Berlin, New York, Paris, Moscow, and beyond. ■ TZARA built on the Symbolism of MALLARMÉ and the concrete typography of MARINETTI and APPOLLINAIRE. He took phrases from contemporary advertising and journalism and combined them in disjunctive verses. Asserting the movement's deliberately commercial texture, TZARA wrote in his 1918 *Dada Manifesto:* "DADA is the billboard of abstraction." ■ In Berlin in 1918, JOHANNES BAADER and RAOUL HAUSMANN challenged the objectivity of photography by combining press photos into jarring montages. In Hanover KURT SCHWITTERS pasted bits of printed ephemera into collages; in 1919 he adopted the word *Merz,* a fragment of the German *Kommerz,* as brand name for his work. ■ Although Dada attacked social institutions and celebrated the irrational side of technology, the movement's illogical use of language influenced artists who professed more rational and utopian views, seeping across the avant-garde network via books, magazines, lectures, congresses, and public spectacles as well as personal letters and "circulars" duplicated on letterhead. ■ In Holland THEO VAN DOESBURG lead a double life as a Dadaist, writing poetry under a pseudonym even while promoting the transcendental harmony of right angles and primary colors. He and his friend SCHWITTERS produced Constructivist typography alongside their Dada performances. While Constructivism clashed with Dada's taste for the erotic and the arbitrary, it shared its contempt for expressionistic individualism. ■ Surrealism, founded in 1924, rejected Dada's theatrical typography in favor of presenting text neutrally, as if it had been transcribed straight from the unconscious. Although Surrealism evolved no distinctive typographic style, its approach to visual imagery was borrowed by advertising designers in the 1930s.

BIBLIOGRAPHY

*Dada and Constructivism.* Tokyo: Seibu Museum, 1988.
Freeman, Judi. *The Dada and Surrealist Word-Image.* Los Angeles: Los Angeles County Museum of Art, 1989.
*Kurt Schwitters.* Valencia: IVAM Centre Julio Gonzalez, 1995.

*Kleine Dada Soirée*
KURT SCHWITTERS (1887–1948) and THEO VAN DOESBURG (1883–1931)
Poster
Netherlands (The Hague), 1922
Lithograph
■ A series of Dada performances were staged across Holland in 1923 by Kurt Schwitters, Theo and Nelly van Doesburg, and Vilmos Huszar. Sitting in the audience, Schwitters would coo like a pigeon and bark like a dog while van Doesburg read from his manifesto "What is Dada?" This poster advertised a "small Dada evening."

**MoUvEmEnT DADA**

BERLIN, GENÈVE, MADRID. NEW-YORK, ZURICH.

PARIS,

**CONSULTATIONS : 10 frs**

S'adresser au Secrétaire
**G. RIBEMONT-DESSAIGNES**
18, Rue Fourcroy, Paris (17e)

**DADA**
Directeur : TRISTAN TZARA

**D₄O⁴H²**
Directeur :
G. RIBEMONT-DESSAIGNES

**LITTÉRATURE**
Directeurs :
LOUIS ARAGON, ANDRÉ BRETON
PHILIPPE SOUPAULT

**M'AMENEZ'Y**
Directeur : CÉLINE ARNAUD

**PROVERBE**
Directeur : PAUL ELUARD

**391**
Directeur : FRANCIS PICABIA

**'Z'**
Directeur : PAUL DERMÉE

Dépositaire
de toutes les Revues Dada
à Paris : Au SANS PAREIL
37, Av. Kléber    Tél. : PASSY 25-22

*tt*

TRISTAN TZARA (1896–1963)
Logo for letterhead
France (Paris), c. 1920
Letterpress

*MoUvEmEnT DADA*
TRISTAN TZARA
Letterhead
France (Paris), c. 1918
Letterpress
■ Tzara underscored the internationalism of Dada by listing the cities where the movement was active. Offering "consultations" for ten francs, he ironically implied that a Dada poet could provide expert services, as would a doctor, lawyer, or soothsayer.

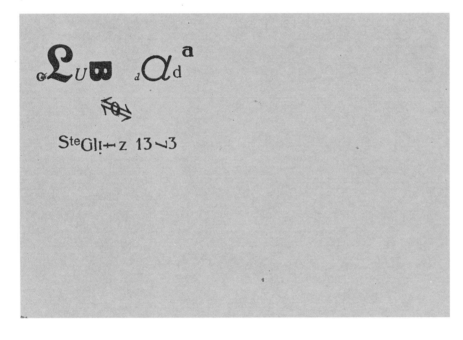

*Club Dada*
JOHANNES BAADER (1876–1955) and
RAOUL HAUSMANN (1886–1971)
Postcard
Germany (Berlin), c. 1919
Letterpress
■ A Dada movement was initiated in
Berlin in 1918 by Johannes Baader,
Raoul Hausmann, Hannah Höch, John
Heartfield, and Richard Huelsenbeck.
Unlike the Dada movements in Paris,
Zurich, and New York, Berlin Dada was
strongly identified with a leftist political
agenda. Founded at the end of World
War I, Berlin Dada reacted against the
war's profound violence and horrific use
of technology. The Berlin Dadaists used
photomontage and mixed typography
to undermine the authority of printed
information.

*Merzverlag*
KURT SCHWITTERS (1887–1948)
Subscription card, front and back
Germany (Hanover), 1923
Letterpress
■ Schwitters founded the magazine
*Merz* in 1923 after touring the
Netherlands with Huszar and the van
Doesburgs, performing their Dada
Soirées. The first issue was devoted to
Dada in Holland.

The subscription card is littered with
logos and promotional copy: "Goals:
Dada - Merz - Style. Motive: World Nation
Feeling ." E. C. K.

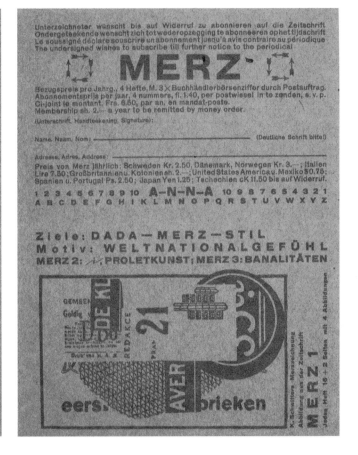

# BUREAU DE RECHERCHES SURRÉALISTES

15, Rue de Grenelle, PARIS (7e)   *SECRÉTARIAT GÉNÉRAL :* **FRANCIS GÉRARD**

*ORGANE MENSUEL :*

# La Révolution Surréaliste

*DIRECTEURS :*
**PIERRE NAVILLE**
ET **BENJAMIN PÉRET**
15, Rue de Grenelle, PARIS (7e)

Paris, le   5 Nov

Monsieur,

Voudriez-vous avoir l'extrême obligeance de porter
à la connaissance de vos lecteurs le communiqué ci-joint.

Veuillez agréer, Monsieur le Directeur, l'assurance
de nos sentiments distingués.

*Benjamin Péret*

*Louis Aragon*
*André Breton*

*Bureau de Recherches Surréalistes*
BENJAMIN PÊRET (1899–1954)
or ANDRÉ BRETON (1896–1966)
Letterhead
France (Paris), c. 1925
Letterpress

■ *La Révolution Surréaliste* was the first
official organ of Surrealism. The objective,
traditional appearance of the publication
reflected the movement's quasi-scientific
"research" into the nature of the uncon-
scious, as well as its rejection of Dada's
exuberant and critical use of typography
and photomontage. The letterhead
features decorative typefaces set in
traditionally centered lines. The effect is
bombastically ordinary.

*Cause Le Surréalisme*
ANONYMOUS
Letterhead
France (Paris), 1940s
Letterpress
■ *Cause Le Surréalisme* was a Surrealist association. The drawing in the lower left is an anthropomorphic machine of ambiguous intent. The slogan that over-prints the red type reads, "The man who walks is a free agent." E. C. K.

BENJAMIN PÊRET (1899–1954)
Letterhead
France (Paris)
Letterpress
Collection W. Michael Sheehe, New York
■ The symbol is based on a passage from Lautréamont: "Turn toward swan lake; and, I will tell you later why, there is among the flock one completely black, bearing an anvil, topped by the putrifying cadaver of a crab, that inspires with good reason the mistrust of the other aquatic comrades."

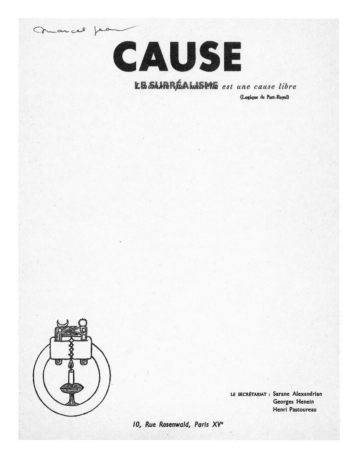

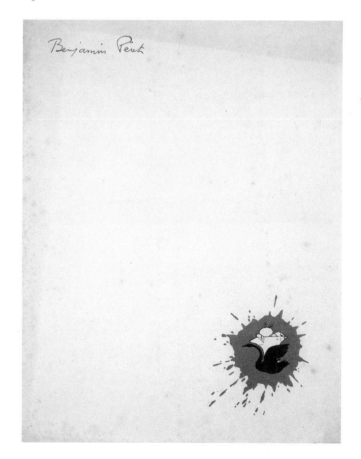

# CONSTRUCTIVISM

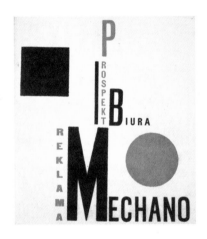

*Reklame Mechano*
HENRYK BERLEWI (1894–1967)
Brochure
Poland (Warsaw), 1924
Letterpress
■ Berlewi applied his theory of
*Mechano-faktura* to painting and
advertising during the 1920s.
Inspired by El Lissitzky, he sought
to create an objective language of
geometric, mechanically produced
forms.

A history of modernism could be told around the contested meaning of the square. In 1915 KASIMIR MALEVICH produced his painting *Quadrilateral,* better known as the "Black Square." The keystone of Suprematism, this zero-degree object was endowed with mystical significance by MALEVICH, who aimed to free art from the burdens of representation and utility. ■ The Black Square was a sublime provocation to younger artists. VLADMIR TATLIN, EL LISSITZKY, ALEXANDER RODCHENKO, and other founders of Russian Constructivism saw concrete tectonics rather than divine spirit in non-objective art. By 1921 public debates between the two camps had left Constructivism with the upper hand, its materialist philosophy more in tune with the new Soviet state. ■ The Constructivists used industrial materials—from steel wire to enamel paint—to ground their objects in physical reality. By the mid-1920s, the Constructivists were increasingly compelled to leave behind the gallery and art exhibition and produce instead posters, publications, kiosks, and exhibitions that promoted the interests of the Soviet government. Type and photography, techniques linked to industrial production, were crucial tools for Constructivist designers. ■ The movement quickly became international, as magazines and artists' groups, many with their own logos and letterheads, appeared in Poland, Hungary, Czechoslovakia, and Germany. LISSITZKY, who worked and travelled extensively in Europe during the 1920s, published his book *Of Two Squares* in Berlin in 1922. The characters in this children's story were made from the anonymous components of typographic production—letters, rules, boxes, and dingbats. *Of Two Squares* was tremendously influential. Translated into Dutch in the magazine *De Stijl,* the book had a strong effect in Holland, where PIET ZWART, whose name means "black," used a black square as a logo on his personal letterhead. ■ Constructivism disappeared in the USSR in the early 30s, after Social Realism was declared the official style of the state.

BIBLIOGRAPHY
Anikst, M. *Soviet Commercial Graphics of the Twenties.* New York: Abbeville Press, 1987.
*Art into Life: Russian Constructivism, 1914–1932.* Seattle: Henry Art Museum, 1990.
Stern, Anatol. "Avant-Garde Graphics in Poland between the Two World Wars." *Typographica* 9 (June 1964): 3-17.

*Dobrolet State Merchant Air Service*
ALEXANDER RODCHENKO (1891–1956)
Letterhead
USSR (Moscow), 1923
Letterpress
■ Rodchenko designed a series of posters, logos, and letterheads for Dobrolet, the state-owned airline, which competed with private airlines in the Soviet Union. Rodchenko designed the logo for this letterhead; the typography probably was determined by a commercial printer.

The New Economic Policy (NEP) was instituted by Lenin in 1921 to stimulate the Soviet economy. It allowed private companies to compete with state-owned businesses. Many progressive artists, inspired by the Communist revolution, created advertising for the state.

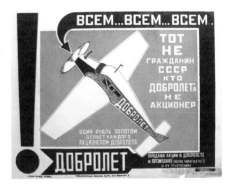

*Dobrolet State Merchant Air Service*
ALEXANDER RODCHENKO
Poster
USSR (Moscow), 1923
Lithograph
■ The text of the poster reads, "To all... To all...To All...He who isn't a stockholder in Dobrolet is not a citizen of the USSR."

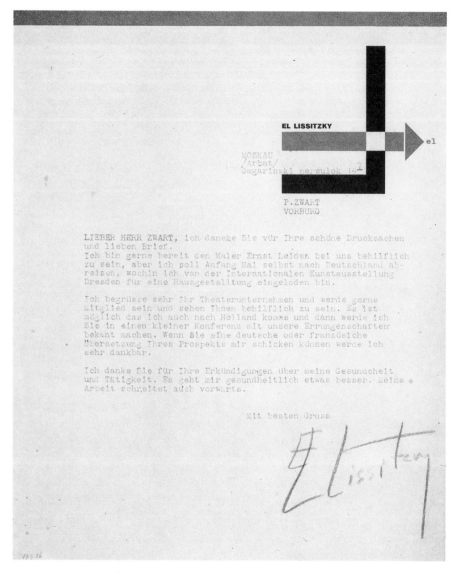

**EL LISSITZKY (1890–1941)**
Letterhead
USSR (Moscow), 1924
Letterpress

■ In this letter to Piet Zwart, Lissitzky thanks Zwart for sending examples of his printed work, and suggests collaborating on future projects. E. C. K.

*Atelier Robertson*
ANONYMOUS
Letterhead
Germany (Berlin)
Letter dated 1929
Letterpress
■ This letterhead indicates the broad influence of El Lissitzky on German design in the 1920s. The overlapping arrow motif lacks the clever construction of positive and negative squares seen in Lissitzky's letterhead.

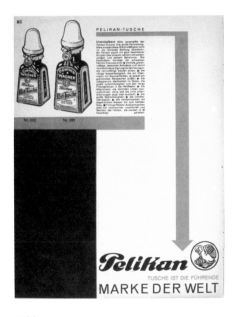

*Pelikan*
EL LISSITZKY
Advertisement
Germany (Hanover), 1924
Letterpress
■ Lissitzky had several commercial clients in Germany during the 1920s. Günther Wagner was the maker of Pelikan inks. Lissitzky designed this ad for Pelikan as part of a special issue of the magazine *Merz*, published by Kurt Schwitters.

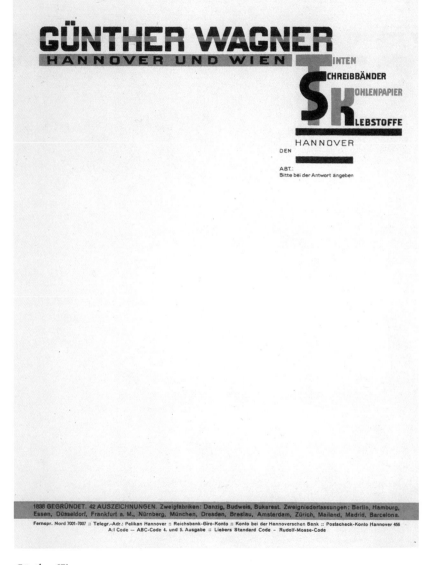

*Günther Wagner*
EL LISSITZKY
Letterhead
Germany (Hanover), 1924
Letterpress
Collection W. Michael Sheehe, New York

*Vesc/Objet/Gegenstand*
EL LISSITZKY
Letterhead and publication
Germany (Berlin), 1922
Letterpress
Letterhead from the collection of
Hans Berndt, Germany
■ *Vesc* was a tri-lingual journal established
in Berlin by El Lissitzky and Ilya
Ehrenburg. *Vesc* advanced the unity of
the artist with the scholar, engineer, and
worker. J. E.

*G, Periodical of Elemental Formation*
HANS RICHTER (1888–1976), publisher
Letterhead
Germany (Berlin), c. 1923
Letterpress
■ Edited by Hans Richter, *G* was
established in response to the Düsseldorf
Congress of Progressive Artists in 1922.
At this international meeting, Richter,
Lissitzky, and Van Doesburg broke off
from the dominant group and articulated
a Constructivist position.

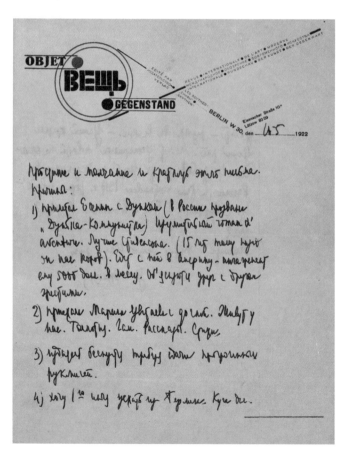

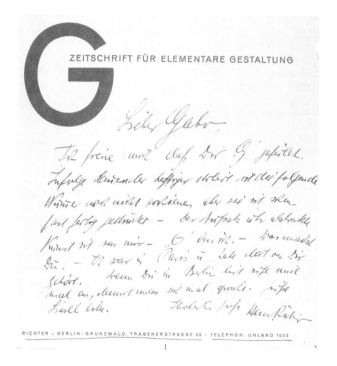

In the magazine's first issue, Van
Doesburg wrote that *G* "owes its existence
to an overall optimism about the means
and possibilities of our time. This
optimism consists before all else in the
following: in still having the wish to
diagnose the possibility of a culture in
the unholy chaos of our age."

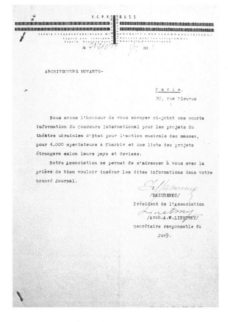

*Association Ukrainienne*
A. STRACHOV
Letterhead
Ukraine (Kharkov), 1930
Letterpress

*Prospectus for the International Competition,
State Ukrainian Theater*
A. STRACHOV
Book
Ukraine (Kharkov), 1930
Letterpress
■ The Ukrainian Association for Scientific
and Intellectual Relations with Foreigners
held an architectural competition for a
4,000-seat theater in 1930. The letterhead
is bilingual, and the *Prospectus* appears in
five languages. Competitions were part of
the international network of avant-garde
communications. While the *Prospectus* is
ambitiously designed, the letterhead
resembles an ordinary printer's job, apart
from the red rules that emphatically
cross through the main text.

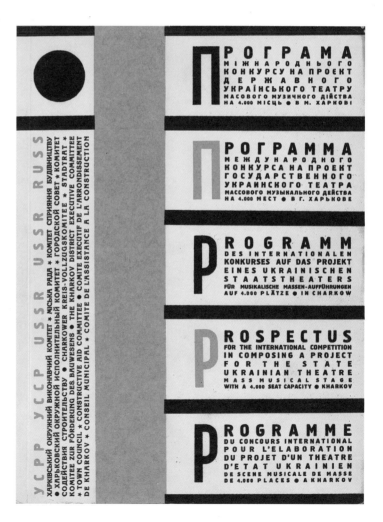

*MA Aktivista Folyoirat*
LAJOS KASSAK (1887–1967), editor
Letterhead
Austria (Vienna)
Letter dated 1923
Letterpress
■ The periodical *MA* (TODAY) was founded
by Lajos Kassak in Budapest, 1916. Kassak
was exiled to Vienna in 1920, where he
continued to publish *MA*, with articles in
Hungarian, German, French, and Italian
on theater, music, and literature.

*MA Aktivista Folyoirat*
LASZLO MOHOLY-NAGY (1895–1946)
Periodical
Austria (Vienna), 1922
Letterpress
■ Moholy-Nagy, a native of Hungary,
contributed this Constructivist design
for a cover of *MA*.

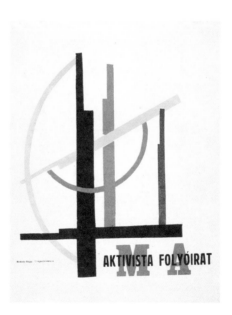

*Katalog Wystawy Nowej Sztuki*
WLADISLAW STREZMINSKI (1893–1952)
and W. KAJRUKSZTIS
Booklet
Poland (Vilno), 1923
Letterpress
■ The *New Art Exhibition* was held in Vilno in 1923. The small-scale catalogue for the exhibition (165 x 122 mm) is a visual and verbal manifesto for Constructivist art. Strezminski, an admirer of Malevich, rejected the "productivist" insistence that art be socially engaged. He founded the movement Unism in 1928, which promoted non-objective art as an end in itself.

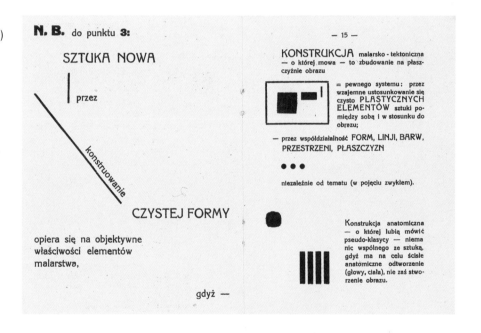

"*Nota bene* to point 3:
New art through construction
of pure form
is based on the objective reality of the elements of painting, because painto-techtonic construction of which I am speaking is built on the surface of the painting. [ ] = a certain system: through mutual relationships of purely plastic elements of art between each other and in relation to the picture. Through the simultaneous interaction of form, line, color, space, and surface...independent of content (in the usual sense)...."

*"a.r." Grupa Sztuki Nowoczesnej*
HENRYK STAZEWSKI (b. 1884)
Letterhead
Poland (Warsaw), 1932
Letterpress
■ The "a.r." Group for New Art was founded
by Wladislaw Strezminski, Katarzyna Kobro,
and Henryk Stazewski in 1930. Their journal
featured experimental art, poetry, sculpture,
and typography. The group established a
permanent museum collection of modern
art in Lodz.

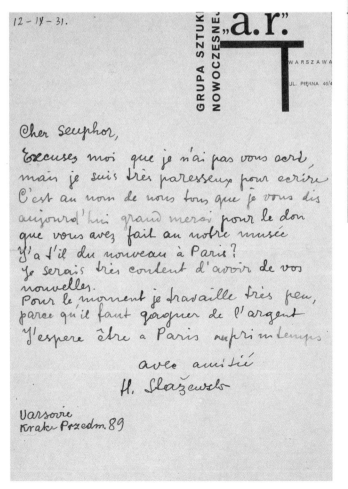

*"Grafika"*
STANISLAWA KOLODZIEJCZAKA
Letterhead
Poland (Lodz)
Letterpress

*St. Weigt i S-ka*
S. GROMIEC
Letterhead
Poland (Lodz)
Letterpress

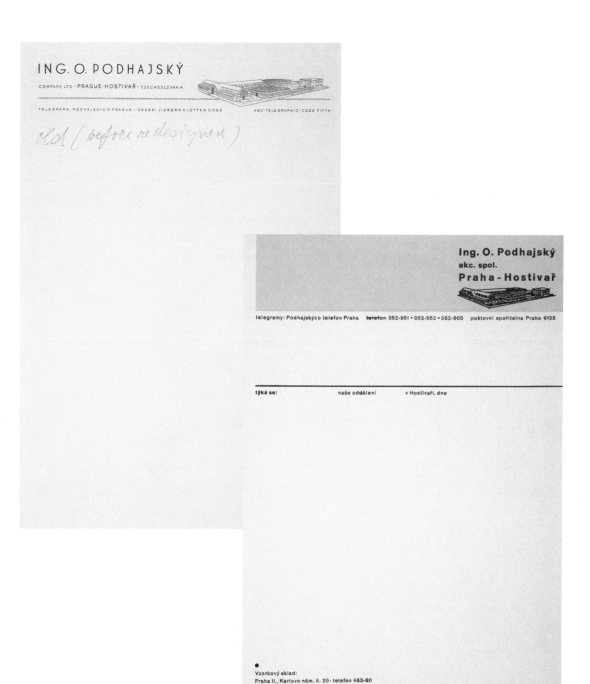

*Ing. O. Podhajsky*
ANONYMOUS
Letterhead
Czechoslovakia (Prague)
Engraving

*Ing. O. Podhajsky*
LADISLAV SUTNAR (1897–1976)
Letterhead
Czechoslovakia (Prague), 1920s
Letterpress
Collection Cooper-Hewitt, National
Design Museum, Smithsonian Institution
■ Sutnar has taken the basic elements
from the older letterhead and rearranged
them in a manner reflecting the theories
of Jan Tschichold and others. The page
has been divided into functional zones.
The drawing of the factory—a staple
of the printer's vernacular—remains part
of the new design. Sutnar was a major
advocate of Constructivism in Czecho-
slovakia during the 1920s and 1930s.
He emigrated to the U.S. in 1939.

# DUTCH MODERNISM

BIBLIOGRAPHY

Broos, Kees. "From De Stijl to a New Typography." *De Stijl, 1917–1931: Visions of Utopia.* Ed. Mildred Friedman. Minneapolis: Walker Art Center, 1982.

Oldewarris, Hans. "Wijdeveld Typografie." Special issue of *Forum.* xxv, 1 (1975).

Purvis, Alston W. *Dutch Graphic Design, 1918–1945.* New York: Van Nostrand Reinhold, 1992.

*Voor bilde dagen gejuktelegrammen*
PIET ZWART (1885–1977)
Poster
Netherlands, 1931
Offset lithograph
■ This poster for the PTT, Holland's telegraph and telephone company, promotes the use of decorated "greeting telegrams."

The fulcrum of the Dutch avant-garde was De Stijl, founded by THEO VAN DOESBURG in 1917. He promoted the De Stijl philosophy through a magazine with same name, maintaining subscriptions and correspondence with visually coordinated letterheads and postcards. De Stijl aimed to transcend individual artistic sensibilities by reducing the vocabulary of art and design to an orthagonal grid and primary colors. VAN DOESBURG believed that De Stijl would restructure all the arts, from architecture to typography. Members of the group included the architect JAN WILS, the furniture maker GERRIT REITVELD, and the painter PIET MONDRIAN, a skeptical participant who was wary of VAN DOESBURG's eclectic interests and avid taste for publicity. ■ VILMOS HUSZAR's 1917 logo for *De Stijl* initiated the movement's typographic method: to build letterforms around a geometric armature. By using the structural characteristics of individual letters as the basis of typographic invention, De Stijl followed the path of Jugendstil and Art Nouveau, which had approached the letter as a decorative organism subject to internal revision. A similar method animated the pages of *Wendingen,* a journal of art and design founded by H.TH.WIJDEVELD in Amsterdam in 1918. WIJDEVELD took the small rectilinear elements found in a typical printer's type case and used them as the molecular units of borders and letterforms—thus he generated dense ornamental detail out of a minimal vocabulary of geometric forms. ■ Although De Stijl maintained a narrow focus in its early years, VAN DOESBURG was eager to extend the international relevance of his movement. He tapped energy from across the network of the avant-garde, drawing ideas from Russian Constructivism's materialist geometries and Dada's attack on individualism. In the early 1920s, VAN DOESBURG and PIET ZWART shifted their attention from the design of individual letters and symbols to the spatial arrangement the anonymous elements from the printer's typecase.

H. TH. WIJDEVELD
Logo for letterhead
Netherlands (Amsterdam),
before 1930
Letterpress

*Dr. H. P. Berlage*
ANONYMOUS
Letterhead
Netherlands (Gravenhage)
Letter dated 1924
Letterpress
■ Many avant-garde designers and
architects in Holland began their careers
working in the architectural office
of Berlage, leader of the "Amsterdam
School." Berlage's letterhead has a
functional vernacular design.

*Wendingen*
H. TH. WIJDEVELD (1885–1987)
Letterhead
Netherlands (Amsterdam)
Letter dated 1924
Letterpress
■ Wijdeveld used metal bars and rules
from the printer's type case to create
geometric letters and an ornamental
border for this square letterhead.
The visible seams between the chunks of
lead give tactile complexity to the design.
Paul Schuitema described the work of
Wijdeveld as "lyric, anti-social, romantic,
passive, symbolic, and aesthetic,"
in contrast with the "realistic, direct,
business-like, active, practical, and
competitive" work of Zwart and others.

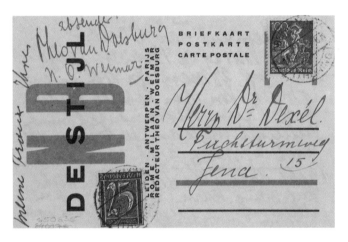

*De Stijl*
VILMOS HUSZÁR (1884–1960)
Logo for publication
Netherlands (Delft), 1917
■ Huszar's hand-drawn logo for the
magazine applied principles from
De Stijl painting to the construction
of letterforms.

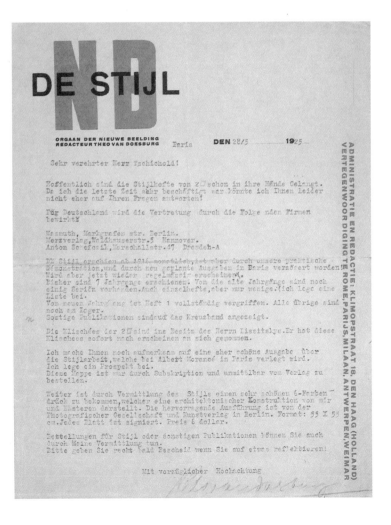

*De Stijl NB*
THEO VAN DOESBURG (1883–1931)
Postcard and letterhead
Netherlands (The Hague and Leiden), 1920
Letterpress
Postcard from the collection of
Getty Center for the History of Art and
the Humanities, Santa Monica
Letterhead from the collection of
Bruno Monguzzi, Switzerland
■ After Van Doesburg redesigned the logo
for *De Stijl* in 1920, Huszar cancelled his
subscription in protest. Mondrian, who had
participated in the redesign, applauded the
change in a warm note to Van Doesburg.
J. E.

*Hagemeijer & Co Exporteurs*
THEO VAN DOESBURG
Letterhead
Netherlands (Amsterdam), 1919
Letterpress
■ Van Doesburg constructed this alphabet
entirely from perpendicular elements. In
a method resembling the digital distortion
of typefaces today, Van Doesburg freely
compressed and extended his letters, as
seen in the narrower forms employed in
the address *"Prins Hendrikkade 159."*

*Jan Wils Architect B.N.A.*
PIET ZWART (1885–1977)
and JAN WILS (1891–1972)
Postcard
Netherlands (Voorburg), 1920
Letterpress
■ Zwart, trained as an architect, worked
in the office of Jan Wils, a member
of the De Stijl group, from 1919 to 1921.
Wils designed the box-like symbol on
this postcard, and Zwart created the
typographic layout. It was one of Zwart's
first experiences with graphic design.

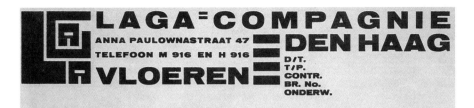

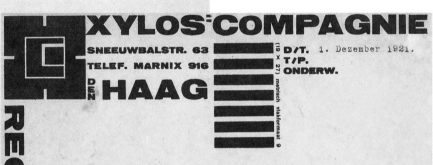

*Laga-Compagnie*
PIET ZWART
Letterhead
Netherlands (The Hague), 1922
Letterpress
■ For this manufacturer of rubber floors, Zwart made a logotype out of interlocking squares.

*Xylos Compagnie*
PIET ZWART
Letterhead
Netherlands (The Hague), c. 1920
Letterpress
Collection W. Michael Sheehe, New York
■ In his designs for Laga Compagnie and Xylos Compagnie, Zwart developed the approach initiated in the postcard for Jan Wils into more complex, densely patterned forms.

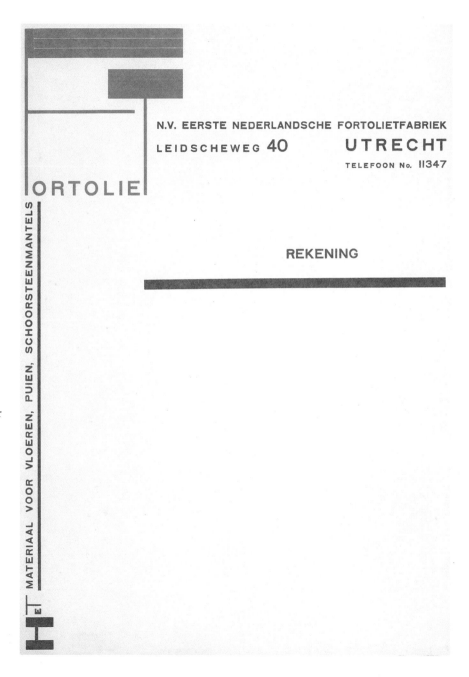

*Fortoliet*
PIET ZWART
Invoice
Netherlands (Utrecht), 1925
Letterpress
■ Zwart's typographic designs became
increasingly free after 1923, reflecting
the influence of El Lissitzky. To create
a letterhead for Fortoliet, a manufacturer
of flooring, Zwart built monumental
letters out of rectilinear elements. While
he had used a similar strategy for Laga
and Xylos, the new forms were elegantly
slim and open. In contrast with the earlier
designs, which are constructed like
tight mosaics, the Fortoliet letterhead
incorporates surprising shifts in weight
and scale.

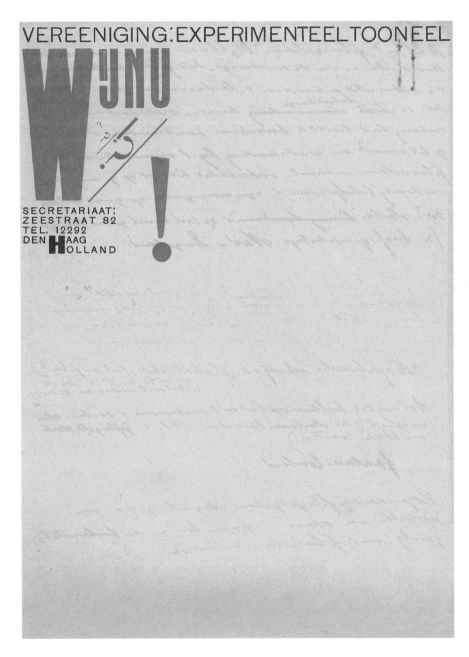

*Wij Nu Experimenteel Tooneel*
PIET ZWART
Letterhead
Netherlands (The Hague), 1925
Letterpress
■ Zwart allowed the spirit of Dada to enter his work for the *Wij Nu Experimenteel Tooneel* (We Now Experimental Theater). The letterhead incorporates nonsensical punctuation and elements set on a diagonal. The capital "H" shared by the words *"Haag"* and *"Holland"* is pieced together from smaller rectangles of lead. The visible seams recall the technique of Wijdeveld.

*NKF Nederlandsche Kabelfabriek*
PIET ZWART
Letterhead
Netherlands (Delft), 1927/1928
Letterpress
■ Zwart produced advertisements, posters,
brochures, and stationery for the Nether-
lands Cable Works from 1923 to 1933.
Zwart wrote, "The more uninteresting
a letter, the more useful it is to the
typographer."

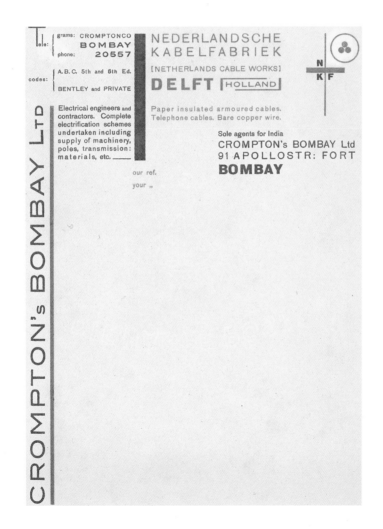

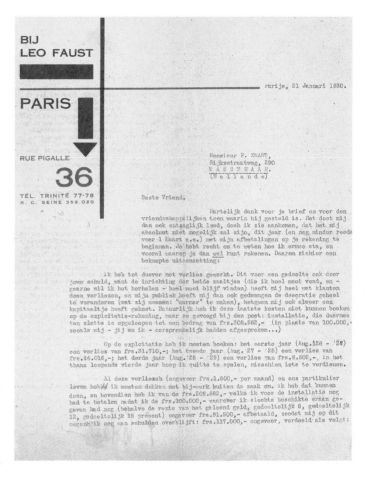

*Bij Leo Faust*
PIET ZWART
Letterhead
France (Paris)
Letter dated 1930
Letterpress
■ Zwart was concerned with the typed
letter as a total composition. The first
paragraph is dramatically indented, and
the body of the letter extends close to the
right edge. The page is like a painting.

*Trio*
ANONYMOUS
Letterhead
Netherlands (Amsterdam), before 1932
Letterpress

*Trio*
PIET ZWART
Printer's proof for letterhead
Netherlands (The Hague), 1932
Letterpress
■ Zwart's design for Trio can be
compared to the company's earlier
letterhead, in which the typographic
elements are forced to fill up the margin.
In contrast, Zwart's design punctuates
the square field with contrasting notes
of thick and thin that divide the page
into zones.

*P. Zwart – Interieur-Architect*
PIET ZWART
Letterhead
Netherlands (Voorburg)
Letterpress
Letter dated 1921
■ Zwart was trained as an architect, and
he continued to draw on the prestige of
the title even after graphic design became
his principal occupation.

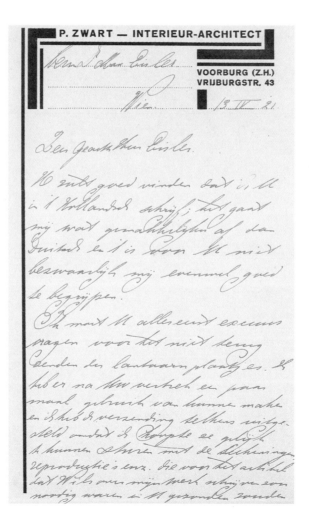

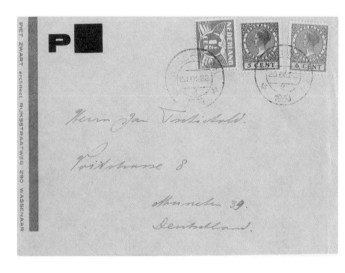

*Piet Zwart architect*

PIET ZWART
Letterhead and envelope
Netherlands (Wassenaar), c. 1928
Letterpress
Collection Getty Center for the History
of Art and the Humanities, Santa Monica
■ In this 1931 letter to Tschichold, Zwart
writes that he is sending examples of his
new work to be included in an upcoming
publication. He also offers a brief critique
of Tschichold's most recent book, *Eine
Stunde Druckgestaltung* (1930). J. E.

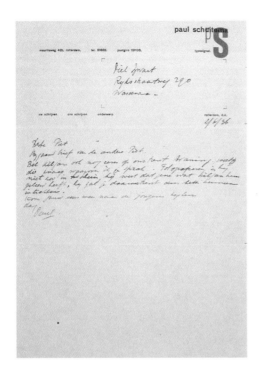

PAUL SCHUITEMA (1897–1973)
Letterhead
Netherlands (Rotterdam)
Letterpress
Letter dated 1936
■ Trained as a painter, Schuitema was
working as a graphic designer by 1924.
He was influenced by Russian
Constructivism and its Dutch variants.

*Kodowa refrigerator comp. Ltd*
PAUL SCHUITEMA
Letterhead and logo for envelope
England (London), late 1920s
Letterpress
■ Schuitema worked for several industrial
clients, including the Van Berkel Meat
Company and Kodowa, a manufacturer
of refrigerators.

*Reclame Ontwerper*
THON DE DOES
Letterhead
Netherlands (Rotterdam)
Letter dated 1930
Letterpress
Collection Michael Sheehe, New York
■ This letterhead for a little-known
advertising designer is unusual for its
brilliant color and its boldly constructed
alphabet. Milton Glaser's typeface Baby
Teeth, designed in the late 1960s, is
remniscent of the strange lettering seen
here.

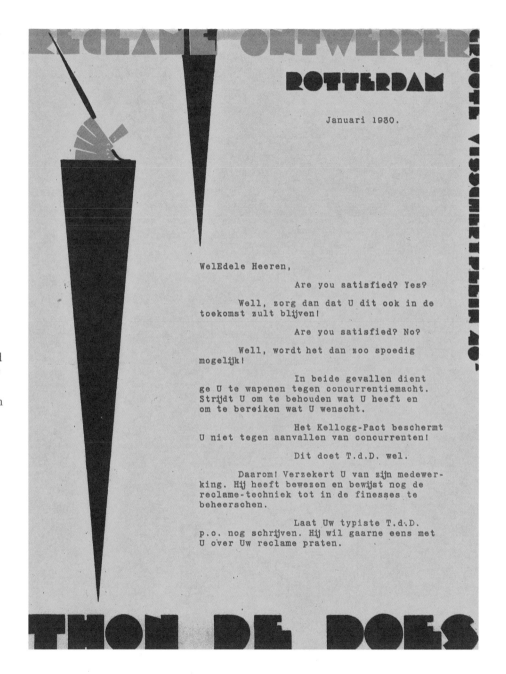

*Het Overzicht*
JOSEF PEETERS (1895–1960)
Publication
Belgium (Antwerp), 1922
Lithograph
■ *Het Overzicht* (The Overview) was an
avant-garde magazine.

*Het Overzicht*
JOSEF PEETERS
Postcard
Belgium (Antwerp)
Posted in 1923
Letterpress
■ The block of hand-drawn text feels as
if it has been "carved" out of a square.

*Werkman/Y*
H. N. WERKMAN (1882–1945)
Letterhead
Netherlands (Groningen)
Letter dated 1927
Letterpress with blocks of wood
Collection Michel Seuphor, Paris

H. N. WERKMAN
Letterhead
Netherlands (Groningen)
Letterpress
Letter dated 1930
Collection Michel Seuphor, Paris
■ These letterheads reflect the expressive,
painterly quality of Werkman's
typography, which rejected the functional
systems of Constructivism and the
geometric programs of De Stijl. Werkman
was executed by the Nazis in 1945 for
producing underground publications.

Groningue le 7 juin 1927.

Monsieur M. SEUPHOR,

23 Rue des Morillons (XV)

PARIS.

Cher Monsieur et Ami.

Vous venez me rappeler à votre lettre de nov.
1926, à laquelle je n'ai pas encore répondu.
Un soir un monsieur, jeune musicien, me vient
visiter, envoyé par votre ami monsieur TONGI
d'Amsterdam, en forme de récherche.
En répondant maintenant, d'abord je vous prie
de vouloir excuser ma négligence. J'avais à
ce temps-là à régler des besognes tellement
désagréables que toute autre chose devait res-
ter au second plan.
Maintenant mon affaire, un imprimerie comme vous savez,
est réorganisé un peu et ça va mieux.
Votre lettre me fait beaucoup de plaisir et je suis heureux
que monsieur DERMÉE aussi s'intéresse à mon travail.
Naturellement je me souviens de votre activité à Anvers.
Avec votre revue "Het Overzicht" en compagnie avec
Peeters vous avez fait un travail très réspectable, qui, sans
doute a eu beaucoup d'influence parmi les jeunes avant-
gardistes.
Si vous voulez organiser à Paris une exposition de mes com-
positions imprimées c'est clair que vous vous trouvez encore
sur les barricades. Ne croyez pas que mon oeuvre soit appré-
cié par le public de Groningue. Ce ne sont, hors de quelques
peintres et architectes une douzaine qui les regardent et
les estiment. Chaque exposition on se trompe à ce point et
ça finit toujours par une condamnation avec tant de mots
dans les journaux. Seulement une foi à Rotterdam par excep-
tion la critique était bienveillante mais je suis toujours
un errant avec un "mauvais goût typografique".
On cherche le typo et oublie le grafique dans mes compositions.
Sans en vouloir augmenter le valeur, je ne doute pas qu'à
Paris, ou on sait mieux de quoi, on ne les niera pas comme
des extravagances. Ni moi ni mon oeuvre ne sont forcés ou
affectés. (Voyez mon dernier portrait, peint par mon ami
Altink, reproduction enclos.)
Je serais très reconnaissant si vous voudriez montrer une
collection à vos amis et organiser une petite exposition
pour moi.
Je travaille constamment après un repos de longue durée
et je pourrais vous envoyer trente ou quarante pièces de
compositions imprimées.
Volontièrement je veux faire en même temp une planche en
couleur pour vos "Documents".
Veuillez agréer, vous et monsieur DERMÉE, mes salutations
cordiales et croyez à mes sentiments devoués.

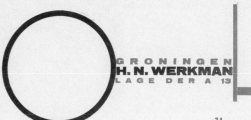

GRONINGEN
H.N. WERKMAN
LAGE DER A 13

31
--
3
--
'30

Waarde vriend Seuphor.

Het eerste nummer van Cercle et Carré ziet er als be-
ginselverklaring uitstekend uit. Bescheiden in omvang
maar van groote beteekenis. Ik hoop dat U voldoende
steun ontvangt om het te kunnen voortzetten. Het is
van veel belang dat dit nummer verschenen is en dat
de tentoonstelling slaagt. Indien het zeker is dst ze
doorgaat is het een daad die zonder twijfel groote ge-
volgen zal hebben en naar ik hoop over geheel Europa
een groote belangstelling en medeleven zal wekken.
Aan de tentoonstelling zal ik gaarne meedoen, hetzij
met nieuw werk, hetzij met dat hetgeen in Uw bezit is.
Als U het laatste goed acht, is mij zulks ook goed.
De prijs zou ik op 300 francs willen vaststellen, wat
is Uw meening daaromtrent.
Ingesloten zend ik U hetinteekenbiljet voor deelname
aan de tentoonstelling ingevuld terug, het bedrag zal
ik dezer dagen aan het bekende adres afzenden.
Hoe is de indruk die het verschenen nummer in Parijs
heeft gemaakt? Ik heb groote achting voor het werken
van al deze menschen en hoop nog eens veel en velen
naderbij te zien en te leeren kennen. Het is hier zoo
ver van de wereld-metro al is het misschien daardoor
wel gemakkelijker tot zelfkennis te komen, gedachten-
wisseling, aansporing, aansluiting en dat alles is er
toch af en toe noodig om tot gedecideerde uitingen te
komen en om er nog meer in mee te leven.

Met beste groeten, succes toegewenscht,

# THE RING

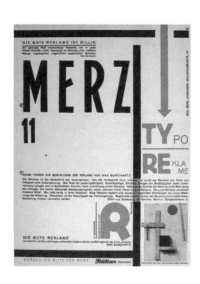

*Merz Eleven*
EL LISSITZKY (1890–1941) and
KURT SCHWITTERS (1887–1948)
Publication
Germany (Hanover), 1924
Letterpress
■ Lissitzky and Schwitters collaborated on this issue of *Merz*, devoted to the subject of typography in advertising.

KURT SCHWITTERS established the *ring "neue werbegestalter"* (circle of new advertising designers) in Hanover in 1928. SCHWITTERS, who had used posters and ads to promote his Dada practice, now sought to advertise the medium of advertising itself by organizing exhibitions and lectures that would promote Constructivist developments in graphic design and typography. ■ With members based across Germany and Holland, the *ring* depended on written correspondence to maintain its unity. The group conducted its business—from assembling exhibitions to soliciting new members—almost exclusively by mail, using an austere, asymmetrical letterhead created by the German designer GEORG TRUMP. It was left to SCHWITTERS to initiate most of the the group's communication, and his carbon-copied letters often closed with pleas for more prompt responses. ■ In 1923 SCHWITTERS had established a commercial design business called Merz Werbezentrale. The firm offered a range of services, from the design of logos and stationery to the production of advertisements, books, and brochures. The journal *Merz,* which SCHWITTERS founded the same year, promoted Dada and Constructivist theories of art and design and sold advertising space to interested vendors. An issue of *Merz* on commercial tyypography was designed in collaboration with LISSITZKY in 1924. According to SCHWITTERS, "Good advertising is cheap, practical, clear, and concise, uses modern means and possesses a powerful form." ■ This commitment to economy and directness was shared by other members of the *ring,* including WILLY BAUMEISTER, WALTER DEXEL, CÉSAR DOMELA, MAX BURCHARTZ, PIET ZWART, and JAN TSCHICHOLD. SCHWITTERS's close friend VAN DOESBURG, who was always safeguarding his own vanguard identity, refused to join. The *ring "neue werbegestalter"* dissolved in 1933, in a political climate that had grown increasingly hostile to modernism.

BIBLIOGRAPHY
Lavin, Maud. "Photomontage, Mass Culture, and Modernity: Utopianism and the Circle of New Advertising Designers." *Montage and Modern Life.* Cambridge: MIT Press, 1992. 37-59.
Lemoine, Serge. "Merz, Futura, Din, and Cicero." *Kurt Schwitters.* IVAM Valencia: Centre Julio Gonzalez, 1995. 507-510.
*Ring "neue werbegestalter" 1928-1933: Ein Überblick.* Hanover: Sprengel Museum, 1990.
*Ring "neue werbegestalter": Die Amsterdamer Austellung 1931.* Wiesbaden: Landesmuseum Wiesbaden, 1990.

*Neue Reklame Merz Werbe*
KURT SCHWITTERS (1887–1948)
Letterhead
Germany (Hanover), c. 1927
Letterpress
■ Schwitters founded the advertising agency Merz Werbezentrale in 1923. Like the magazine *Merz* and Schwitters's other enterprises, the advertising business operated from his home address. The heading *"Neue Reklame,"* meaning New Advertising, proclaims the firm's progressive commercial orientation. Schwitters has placed a small logo in the lower left corner, linked to the address and main title by a long typographic rule. He used similar design structures in his work for the Hanover Town Council in the late 1920s.

*Merz Werbezentrale*
KURT SCHWITTERS (1887–1948)
Envelope
Germany (Hanover), 1924
Letterpress

■ This envelope for Schwitters's advertising agency uses a framework of heavy rules inspired by Constructivism. The word *"Drucksache"* (stationery) is set in a delicate script that contrasts with the rest of the design.

The text that edges the thick red rule announces the firms' services: modern posters, pictorial publicity, typo-logos, logos, packages, catalogues, prices lists, advertisements, lighted signs, texts.
E. C. K.

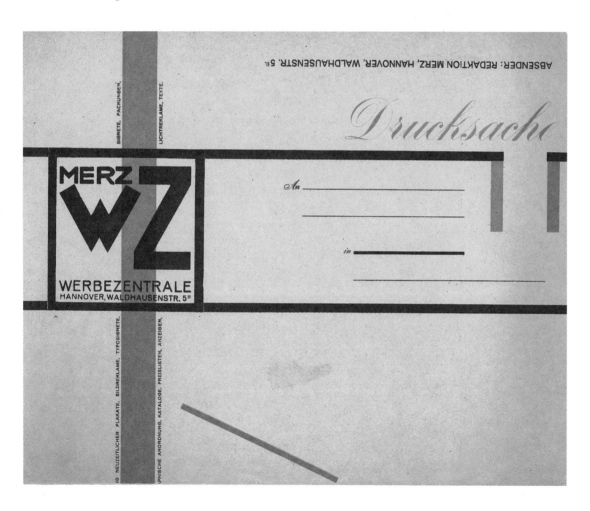

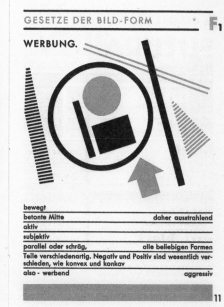

*Werbe-Gestaltung*
KURT SCHWITTERS
Advertising booklet
Germany (Hanover), 1930
■ Schwitters promoted his theories of
design to prospective customers with this
small booklet (151 x 118 mm), which was
mailed in a corresponding envelope.

The sans serif typeface Futura was
designed by Paul Renner in 1928.
Organized around a set of geometric
elements, Futura was embraced by many
avant-garde designers, including
Schwitters, who used it in his important
commission for the Hanover Town
Council in 1929. Schwitters redesigned
the Hanover government's numerous
forms and stationery according to
consistent design standards, making
Futura the city's official typeface.
Nationalist conservatives favored the
gothic type style Fraktur, which they saw
as properly Germanic; they condemned
the internationalism of sans serif and
roman typefaces. Futura was banned in
Hanover by the Lord Mayor in 1933.

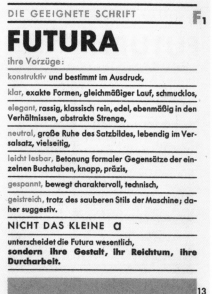

*werbe-bau*
MAX BURCHARTZ (1887–1961)
JOHANNIS CANIS (1895–1977)
Letterhead
Germany (Bochum), 1925/26
Letterpress
■ Burchartz and Canis founded werbe-bau in 1924, one of the first "modern" advertising agencies in Germany. Burchartz focused on design, and Canis specialized in writing copy.

Burchartz wrote that good advertising
"1. is functional
2. is clear and concise
3. uses modern means
4. makes an impact through form
5. is cheap" (1924).  E. C. K.

CÉSAR DOMELA
(1900–1995)
Letterhead
Germany (Berlin),
after 1933
Letterpress
■ Born in the Netherlands, Domela was a self-taught painter and designer who became a member of the De Stijl group in 1925. His design services are listed at edge of his letterhead, including stationery, posters, and photomontage.

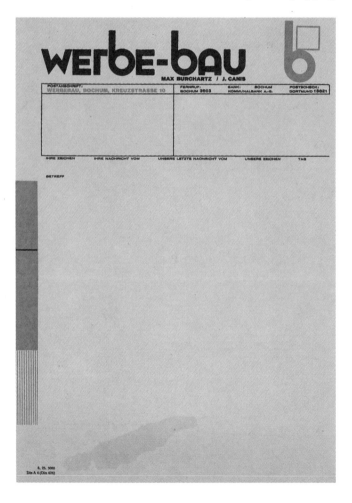

*Neue Reklame - Dr. Dexel*
WALTER DEXEL (1870–1973)
Letterhead
Germany (Jena), 1926
Letterpress
■ As director of the Kunstverein Jena, an exhibition hall, Dexel organized Dada evenings and numerous exhibitions on avant-garde art; he was the first to show Constructivist design in Germany. He was an important link in the network of avant-garde communications. E. C. K.

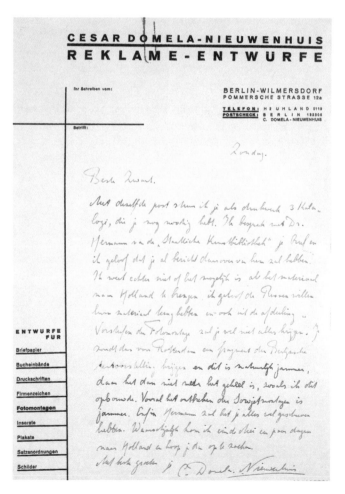

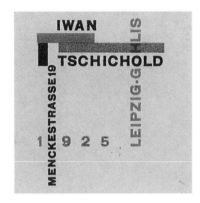

*NWG ring "neue werbegestalter"*
GEORG TRUMP (1896–1985)
Letterhead
Germany (Hanover), c. 1928
Letterpress
The *ring* conducted most of its business
through the mail.

*Iwan Tschichold*
JAN TSCHICHOLD (1902–1974)
Logo for letterhead
Germany (Leipzig), 1925
Collection Getty Center for the History
of Art and the Humanities, Santa Monica
■ Tschichold used the name "Iwan"
beginning in 1924 to signal his allegiance
with Russian Constructivism. J. E.

*jan tschichold ring nwg*
JAN TSCHICHOLD
Letterhead
Germany (Munich), after 1928
Letterpress
■ The initials "nwg" signal Tschichold's
membership in the *ring.*

JAN TSCHICHOLD
Mailing label
Germany (Munich)
Letterpress

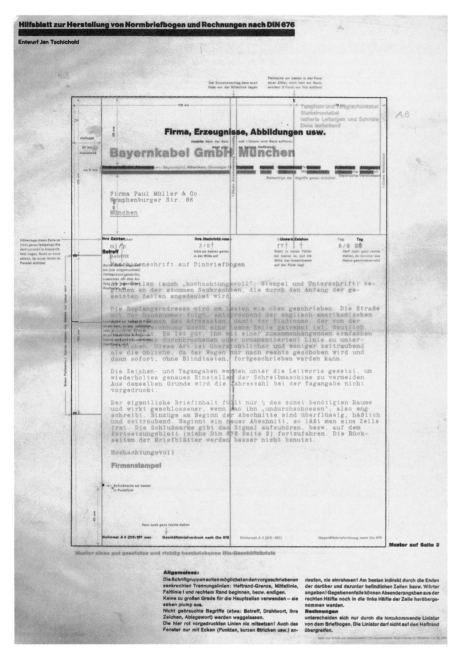

*Typografische Entwurfstechnik*
JAN TSCHICHOLD (1902–1974)
Instruction sheet
Germany, 1932
Letterpress

■ This instruction sheet is printed on two sides of a piece of transparent vellum that has been folded in half. On the top layer is a theoretical diagram annotating the practical example beneath. Tschichold advocated reserving the top third of the page for printed information about the sender (address, phone, etc.), with a space clearly demarcated for typing the receiver's address. He promoted the DIN system of standard sizes, introduced in Germany in the early 1920s. Concerned not only with the printed letterhead but also with how text is positioned on it, Tschichold demanded that the left-hand edge of the manuscript be kept rigorously in line with the margin established by the printed elements.

*Süddeutsche Holzwirtschaftsbank AG*
JAN TSCHICHOLD
Letterhead
Germany (Munich), 1928
Letterpress
■ This letterhead reveals the rigorously quiet manner in which Tschichold applied his theories.

*Meisterschule für Deutschlands Buchdrucker*
JAN TSCHICHOLD
Letterhead
Germany (Munich), 1929

*film und foto*
JAN TSCHICHOLD
Letterhead
Germany (Stuttgart), 1929
■ Members of the *ring* helped organize and
promote several important exhibitions,
including the German Werkbund's *film
und foto*, which included work by a diverse
range of photographers, including Laszlo
Moholy-Nagy, El Lisstizky, Edward
Weston, Hans Richter, and Piet Zwart.

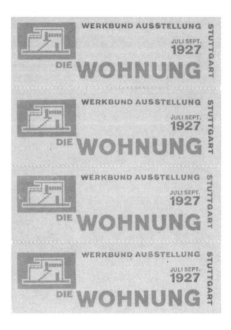

*Die Wohnung*
WILLY BAUMEISTER (1889–1955)
Stamps
Germany (Stuttgart), 1927
Letterpress on gummed paper
■ The Werkbund's 1927 exhibition
*Die Wohnung* (The Dwelling) was an
important event for architects and
designers interested in concepts of worker
housing and the minimal dwelling.

WILLY BAUMEISTER (1889–1955)
Letterhead and envelope
Germany (Stuttgart), 1924
Letterpress
Collection Getty Center for the History of Art
and the Humanities, Santa Monica
■ The block of copy in the upper right lists
Baumeister's design services. He used the large
"B" motif again in letterhead designs for his
brothers, Hans and Gert, and for the exhibition
*Bau-Ausstellung Stuttgart 1924.* J. E.

*Akademischer Verlag*
WILLY BAUMEISTER
Letterhead
Germany (Stuttgart)
Letter dated 1927
■ Baumeister described the designer's
task, "Typography is mostly an act of
dividing a limited surface" (1926).
Here, strong red rules frame the page
and its parts, putting Baumeister's
theory into practice. E. C. K.

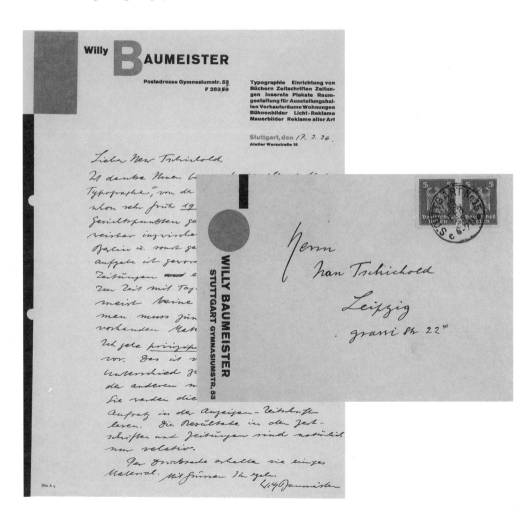

# BAUHAUS

BIBLIOGRAPHY
Lupton, Ellen and J. Abbott Miller, eds. *The ABCs of ●■▲: The Bauhaus and Design Theory.* New York: The Cooper Union, 1991.
Moholy-Nagy, Laszlo. *Painting, Photography, Film.* Cambridge: MIT Press, 1969.
Wingler, Hans. *The Bauhaus: Weimar, Dessau, Berlin, Chicago.* Cambridge: MIT Press, 1969.

As a mythic symbol of modernism, the word "Bauhaus" evokes a monolithic image of tubular furniture and flat-roofed housing. Yet in reality, the Bauhaus did not represent a single philosophy, but responded to a mix of aesthetic and cultural issues. This shifting identity was reflected in the letterheads used by the school and its faculty. ■ The Bauhaus opened in Weimar in 1919, where director WALTER GROPIUS aimed to build an academy that would improve German industrial design. At the center of the Bauhaus curriculum was the *Vorkurs,* or Basic Course, which introduced all students to principles of abstract design and the use of materials. Initially, the Basic Course was controlled by JOHANNES ITTEN, an Expressionist painter whose eccentric and spiritual pedagogy irritated GROPIUS and caused friction with the conservative Weimar community. ■ After ITTEN was pressured to resign in 1923, the Basic Course was taken over by PAUL KLEE, WASSILY KANDINSKY, and LASZLO MOHOLY-NAGY, artists with more analytical teaching methods. Whereas ITTEN had dressed in the flowing robes of a mystic, the Constructivist designer MOHOLY-NAGY wore the functional overalls of an engineer. ■ Although graphic design and typography were not part of the initial curriculum at the Bauhaus, the printing workshop was crucial to the school's economic growth and public image. The Bauhaus Press issued books on art and design by Bauhaus faculty and other members of the international avant-garde. Invoices, letterheads, prospectuses, and catalogues were needed to market the school's program and products. ■ In 1925 the Bauhaus moved to Dessau, an industrial town near Berlin. Two former students, HERBERT BAYER and JOOST SCHMIDT, joined the faculty, teaching a course in typography. The letterheads and logos they created for the school and for commercial clients carried forward MOHOLY's approach to integrating type and image. In 1930 the Bauhaus moved to Berlin; it was forced to close by the Nazis in 1933.

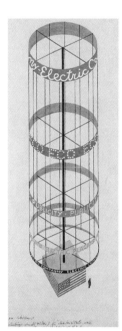

*Advertising Kiosk*
HERBERT BAYER (1900–1985)
Drawing
Germany (Dessau), 1924
Gouache on paper
Masawa Homes' Bauhaus Collection, Japan
■ While Kustav Klustis was designing propaganda kiosks for the Soviet government, Herbert Bayer was designing pavillions intended for commercial advertising. The flag at the base of this multi-media structure reflects the fascination with "Americanism" held by many German modernists.

*Staatliches Bauhaus*
LYONEL FEININGER (1871–1956)
Letterhead
Germany (Weimar), 1918
Woodcut
■ Expressionism dominated the early
years of the Bauhaus. Feininger used the
traditional craft medium of the woodcut
to produce his letterhead. In 1919 he
made a woodcut of a gothic cathedral that
symbolized the merging of all the arts
under architecture at the Bauhaus.

*Staatliches Bauhaus Weimar*
ANONYMOUS
Letterhead
Germany (Weimar)
Letter written in 1923
■ This letterhead reflects the school's lack
of concern for its typographic image prior
to the arrival of Laszlo Moholy-Nagy.

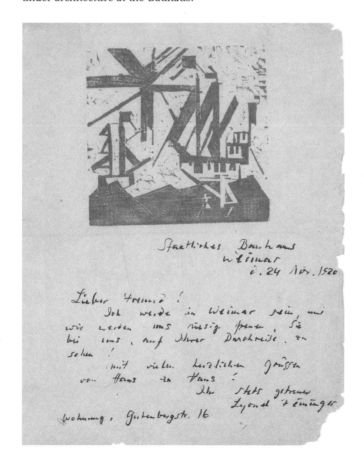

*Die Bauhaus Bücher*
LASZLO MOHOLY-NAGY (1895–1946)
Catalogue
Germany (Dessau), 1927
Letterpress
■ Moholy-Nagy designed books for the
Bauhaus Press as well the letterheads and
catalogues used to market them. In his
books, he employed visual signals such as
heavy rules and boldface typography to
actively organize content. This catalogue
cover explores his theory of "typophoto,"
the integration of type and photography.
Fourteen books were published between
1925 and 1930.

*Bauhausverlag*
LASZLO MOHOLY-NAGY
Letterhead
Germany (Weimar), 1923
Letterpress

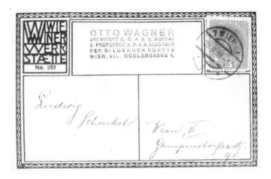

*Das Bauhaus in Dessau*
LASZLO MOHOLY-NAGY
Invoice
Germany (Dessau), 1925
Letterpress
■ The sale of products and services was an important source of revenue and publicity for the Bauhaus. This invoice documents the sale of a doll.

*Wiener Werkstätte*
OTTO WAGNER (1841–1918)
Postcard
Austria (Vienna)
Letterpress
Posted in 1918
■ Wagner was a leading figure in the *Wiener Werkstätte,* founded in 1903. He introduced industrial materials and exposed structural elements into the design of buildings and furniture in the early twentieth century.

*Wiener Werkstätte Gesellschaft*
WIENER WERKSTÄTTE (1903–1932)
Invoice
Austria (Vienna)
Letterpress
Issued in 1929
■ The *Wiener Werkstätte* was an important precedent for the Bauhaus. This association of designers sold textiles and decorative arts to the public.

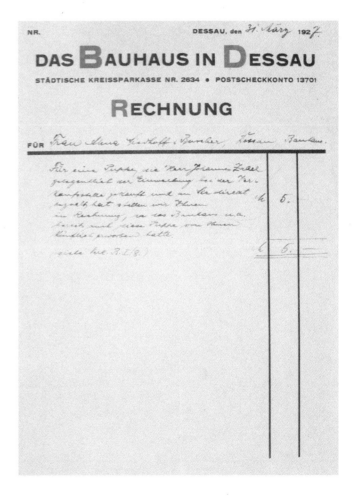

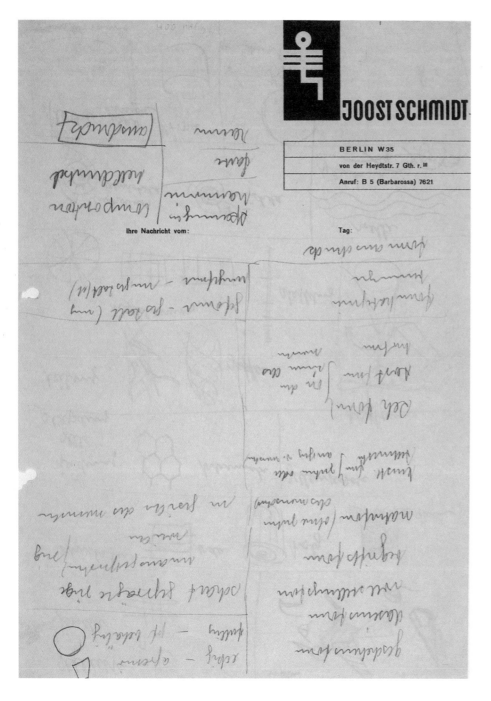

JOOST SCHMIDT (1893–1948)
Letterhead
Germany (Berlin)
Letterpress
Collection Getty Center for the History
of Art and the Humanities, Santa Monica
■ A variation of Schmidt's personal mark
appeared in a poster advertising the first
Bauhaus exhibition in 1923. These notes
concerning various forms of "expression"
and "existence" may have been
preparations for a Bauhaus course.  J. E.

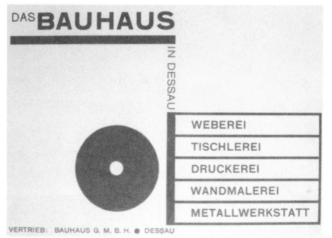

*Das Bauhaus in Dessau*
JOOST SCHMIDT
Postcard
Germany (Dessau), 1925/26
Letterpress

*bauhaus zeitschrift für bau und gestaltung*
HERBERT BAYER (1900–1985)
Periodical
Germany (Dessau), 1928
Letterpress
■ In this self-referential cover for the
*bauhaus* journal, a photograph of
the magazine's logo becomes the logo.
The cover reflects the theory of
"typophoto" espoused by Moholy-Nagy.
The journal promoted the school's ideas
to an international audience.

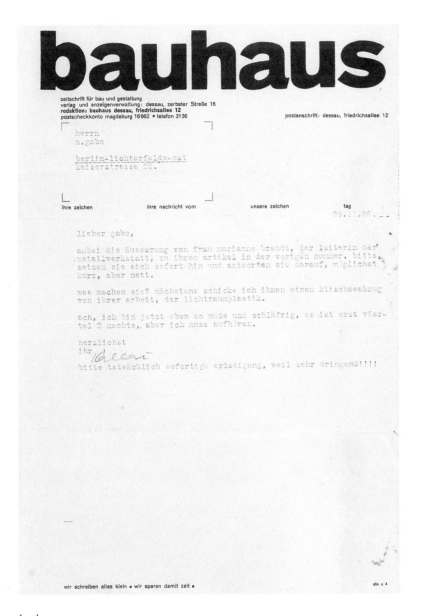

*bauhaus*
HERBERT BAYER
Letterhead
Germany (Dessau), 1927
Letterpress

*der direktor*
HERBERT BAYER
Letterhead
Germany (Dessau), 1924
Letterpress
■ Bayer designed numerous variations of
the letterhead for Walter Gropius, director
of the Bauhaus from 1919 to 1927. The
text at the bottom explains Bayer's attempt
to reform the alphabet by abolishing
capital letters. The letterhead was literally
a manifesto.

LUDWIG MIES VAN DER ROHE
(1886–1969)
Letterhead
Germany (Berlin)
Letter dated 1924
Letterpress
■ Mies van der Rohe became director of
the Bauhaus in 1930. The horizontal
orientation of his letterhead reflects the
character of his architecture.

*bauhaus berlin*
ANONYMOUS
Letterhead
Germany (Berlin), c. 1930
Letterpress
■ The Bauhaus moved to Berlin in 1930
under the direction of Hannes Meyer,
who preceded Mies van der Rohe as
director.

*Puka Reklame*
HERBERT BAYER (1900–1985)
Letterhead and envelope
Austria (Linz), 1923
Letterpress
■ Bayer was one of the most prolific graphic designers at the Bauhaus, with an extensive commercial practice outside the school. He attended the Bauhaus as a student and later became an instructor.

*Ernst Kraus*
HERBERT BAYER
Logo study
Pencil and ink

*Ernst Kraus Glasmaler Weimar*
HERBERT BAYER
Letterhead
Germany (Weimar), 1924
Letterpress
Collection W. Michael Sheehe, New York

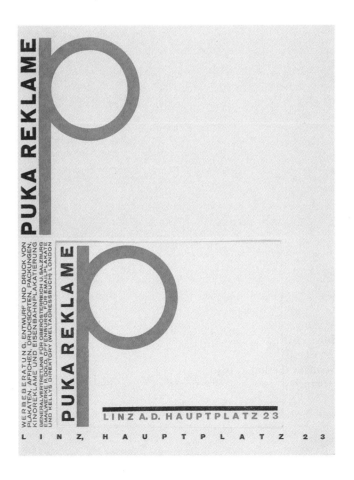

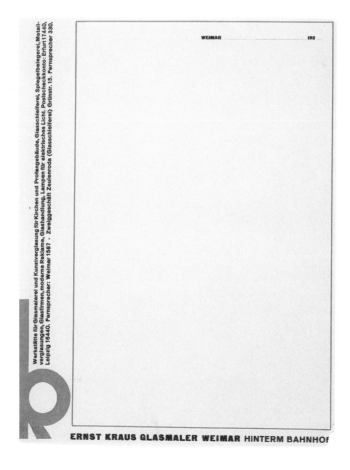

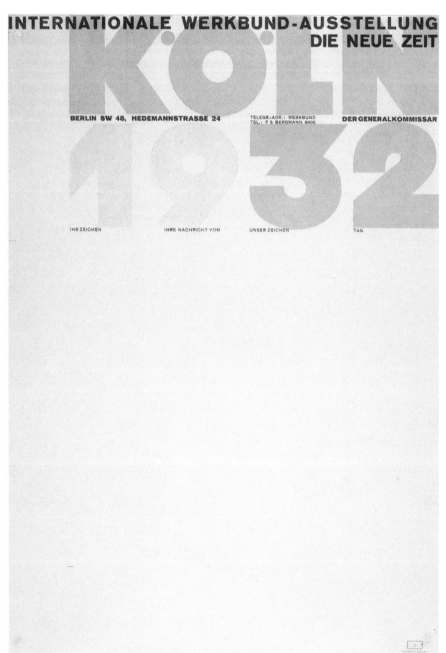

*Köln 1932, Internationale Werkbund Ausstellung*
HERBERT BAYER
Letterhead
Germany (Berlin), 1932
Letterpress
■ The *Werkbund* was an alliance of manufacturers, retailers, and designers that had a strong alliance with the Bauhaus after 1924. Bayer used monumental typography to promote this architectural exhibition.

*Dr. Hittel's Blendax*
HERBERT BAYER
Letterhead
Germany (Berlin), 1933
Offset lithograph
■ While the typography in this letterhead applies the rational zoning of space that is typical of the work of Jan Tschichold and others, the large-scale photographic image is unusual within the context of avant-garde letterheads.

Moholy-Nagy advocated the integration of text and photography. His theory of "typophoto" was applied chiefly to books, magazines, and posters.

*Zieger & Wiegand*
HERBERT BAYER
Letterhead
Germany (Berlin), 1927
Offset lithograph
■ Photography brings a disturbing realism to this letterhead for a manufacturer of rubber goods.

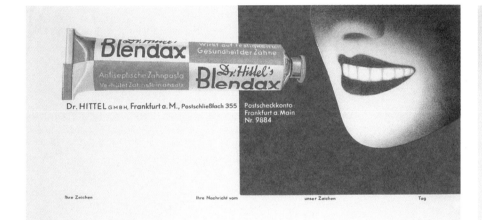

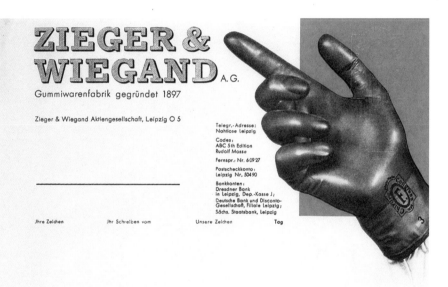

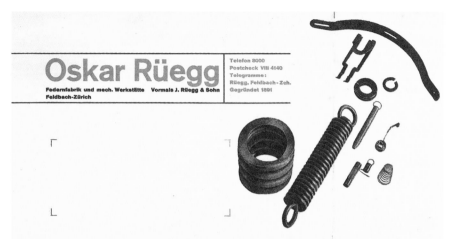

Ich gestatte mir, Ihnen mitzuteilen, dass Herr J. Rüegg sen. zufolge freundschaftlicher Vereinbarung aus der Firma J. Rüegg & Sohn ausgetreten ist.

Das gesamte Geschäft mit Aktiven und Passiven habe ich nunmehr auf eigene Rechnung übernommen, und ich werde es unter der neuen Firma:

Oskar Rüegg,

Federnfabrik & mechan. Werkstätte, Feldbach - Zch.

unverändert weiterführen.

Durch fortwährende Erneuerung des Maschinenparkes, Ersatz von älteren Maschinen durch Halb- oder Ganzautomaten, Rationalisierung, Verfeinerung der Fabrikate in Bezug auf Qualität und Ausführung, bin ich in der Lage, auch den verwöhntesten Ansprüchen gerecht zu werden bei absolut konkurrenzfähigen Preisen.

Ich bitte Sie, Ihr Zutrauen auch der neuen Firma zu schenken und begrüsse Sie

hochachtungsvoll:

*Oskar Rüegg*
ANTON STANKOWSKI (b. 1906)
Letterhead
Germany, 1932
Letterpress
■ Stankowski studied with the graphic designer and painter Max Burchartz, and he worked with Johannis Canis in the late 1920s. Stankowski, who began using photography in his work in 1926, was an important influence on graphic design in Switzerland.

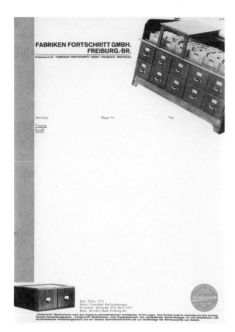

*Fabriken Fortschritt GmbH*
JOHANNIS CANIS (1895–1977)
Letterheads
Germany (Bochum), 1932
Letterpress
Collection Museum für Gestaltung, Basel
■ Canis founded an advertising agency
with Max Burchartz in 1924 and worked
with Anton Stankowski later in the 20s.
This series of letterheads for a manu-
facturer of office furniture uses photo-
graphy in a dramatic way.

**DAS NEUE FRANKFURT**
MONATSSCHRIFT FÜR DIE PROBLEME MODERNER GESTALTUNG

HERAUSGEBER: STADTBAURAT ERNST MAY UND PROFESSOR DR. FRITZ WICHERT
SCHRIFTLEITER: DR. JOSEPH GANTNER NEUE MAINZERSTRASSE 37

VERLAG ENGLERT & SCHLOSSER, FRANKFURT A. M., MÖRFELDERLDSTR. 109 · POST-
SCHECK: FRANKFURT a. M. 45083 · BANK.K.: FRANKFURTER GENOSSENSCHAFTSBANK
FRANKFURT AM MAIN, DEN 28 mars 1928

DIE SCHRIFTLEITUNG

A la rédaction de l a revue«L'Architecture vivante»
Ed.Albert Morancé
P a r i s
30 rue de fleurus

Monsieur le directeur et cher collègue,

à la fin de l'année passée nous nous sommes adressés à vous pour vous
proposer un échange régulier de votre intéressante revue avec «Das
Neue Frankfurt». Depuis ce temps-là, notre éditeur vous a envoyé les
fascicules de notre revue. D'autre part nous n'avons reçu aucune ré-
ponse de vous, de sorte que nous nous permettons de renouveler la pro-
position d'un échange. A notre très grand regret il nous serait im-
possible de vous envoyer dorénavant notre revue sans que nous recevri-
ons la vôtre.

Veuillez agréer, Monsieur le directeur et cher collègue, l'expression
de mes meilleurs sentiments

*Das Neue Frankfurt*
ANONYMOUS
Letterhead and envelope
Germany (Frankfurt A.M.)
Letterpress
Posted in 1928

*Das Neue Frankfurt*
H. LEISTIKOW (1892–1962)
Periodical
Germany (Frankfurt A.M.), 1928
Letterpress
The journal *Das Neue Frankfurt* was
inspired by the activities of the Bauhaus.
*Das Neue Frankfurt* published articles
on architecture, interiors, film, and other
forms of "design for the metropolis."
Like other avant-garde publications,
it was distributed through the mail to an
international audience.

# ARCHITECTURE + DESIGN IN FRANCE

*Pavilion L'Esprit Nouveau*
LE CORBUSIER (1887–1965)
Architectural sign
France (Paris), 1925
■ The Pavilion L'Esprit Nouveau
was presented at the 1925
*Exposition Internationale des Arts
Décoratifs* in Paris. Conceived
as a modular unit from a grand
housing scheme, the Pavilion
had huge letters emblazoned
in its windows. This dramatic
lettering emphasized the
promotional nature of the
exhibit.

The "New Typography" of Jan Tschichold and the Constructivists attracted little interest in France. Poster artists such as A. M. CASSANDRE focused on image-making, finding their primary aesthetic inspiration in modern French painting rather than experimental typography. ■ The great innovators in design were architects such as PIERRE CHAREAU and LE CORBUSIER. Like CASSANDRE, CORBUSIER created paintings that turned the hermetic language of Cubism into a legible vocabulary of simple, abstracted objects. While CORBUSIER's paintings resembled France's progressive commercial illustration, he was developing, at the same time, a practice as a publisher and advertising designer that was innovative not so much for its style as for its active enagement of modern publicity techniques. Issued from 1920 to 1925, CORBUSIER's magazine *L'Esprit Nouveau* tested the boundaries between editorial and advertising, journalism and self-promotion. ■ In his writings on design, CORBUSIER identified certain utilitarian objects as embodying the spirit of the current age: "Our modern life...has created its own objects: its costume, its fountain pen, its eversharp pencil, its typewriter, its telephone, its admirable office furniture, its plate glass and its 'Innovation' trunks...." In these objects—useful, anonymous, unpretentious—CORBUSIER saw the seeds of modern architecture. ■ Using letterheads that matched the identity of *L'Esprit Nouveau*, he maintained an active correspondence with the makers of such industrial goods, building voluminous files of product literature from which he illustrated his articles and books. He also solicited advertising accounts from these companies—his service included writing and designing the ads to appeal to the journal's specialized readership. ■ *L'Esprit Nouveau* and other French periodicals, including *L'Architecture D'Aujourdhui* and *Cercle et Carré,* served to build a communications network for progressive architects and designers, which linked the discourse of modernism to the cultures of mass production and publicty.

BIBLIOGRAPHY

Colomina, Beatriz. *Privacy and Publicity: Modern Architecture as Mass Media.* Cambridge: MIT Press, 1994.

Le Corbusier. *Towards a New Architecture.* New York: Dover, 1986.

*L'Esprit Nouveau*
LE CORBUSIER
Letterhead
France (Paris), 1920
Letterpress

■ In the letterhead below, the particulars have been updated by hand. One of the director's names has been crossed out— *guilliotiné.*

*L'Esprit Nouveau*
LE CORBUSIER
Letterhead
France (Paris)
Letter dated 1921
Letterpress

■ The letterhead includes a tiny graph documenting the recent rise in the magazine's subscriptions. The graph reflects *L'Esprit Nouveau's* scientific aspirations and promotional zeal.

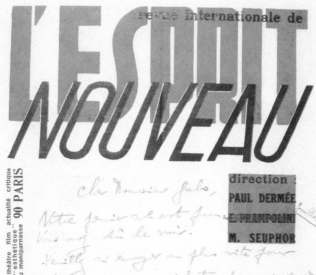

*L'Esprit Nouveau*
LE CORBUSIER
Letterhead
France (Paris), before 1925
Letterpress

## L'ARCHITECTURE D'AUJOURD'HUI
REVUE MENSUELLE D'ARCHITECTURE CONTEMPORAINE ★ 5, RUE BARTHOLDI, BOULOGNE (SEINE) ★ TÉL. : MOLITOR 31-71

ANDRÉ BLOC, DIRECTEUR GÉNÉRAL
PIERRE VAGO, PRÉS. DU COMITÉ DE RÉDACTION ★ A. PERSITZ, RÉDACTEUR EN CHEF

Comité de Patronage : MM. Pol Abraham, Alfred Agache, Colonel Antoine, Léon Bazin, Eugène Beaudouin, Auguste Bluysen, Louis Baileau, Victor Bourgeois, Urbain Cassan, Pierre Chareau, Jean Demaret, Jean Desbois, W. M. Dudok, Félix Dumail, B. Elkouken, Roger H. Expert, E. Freyssinet, Tony Garnier, Jean Ginsberg, Jacques Guilbert, Marcel Hennequet, Roger Hummel, Pierre Jeanneret, Francis Jourdain, Albert Laprade, Le Corbusier, Henri Le Même, Marcel Lods, Berthold Lubetkin, André Lurçat, Robert Mallet-Stevens, Léon-Joseph Madeline, Louis Madeline, J.-B. Mathon, Jean-Charles Moreux, Pierre Patout, Auguste Perret, Eugène Petit, G.-H. Pingusson, Henri Prost, Maurice Rotival, Michel Roux-Spitz, Jean Verrer, G.-P. Sébille, Paul Sirvin, Joseph Vago, André Ventre, Willy Vetter.

4691/Y.C.                                     Boulogne, le 11 Septembre 1947

Monsieur Frederick J. KIESLER
Hôtel Lutetia
PARIS  7°
----------

Cher Monsieur,

        Me voici de retour à Paris, et j'espère que
vous êtes encore ici pour quelques semaines ou quelques
jours, et j'aimerais vous rencontrer avant votre départ.

        Veuillez me fixer un rendez-vous à votre
convenance, je suis à votre disposition.

        Dans cette attente, je vous prie de croire,
Cher Monsieur, à mes sentiments les meilleurs.

                        A. BLOC

COMPTE CHÈQUES POSTAUX PARIS 1519-97 ★ REGISTRE DU COMMERCE DE LA SEINE 485.990

*L'Architecture d'Aujourd'hui*
ANONYMOUS
Letterhead
France (Boulogne)
Letter dated 1931
Letterpress
Collection W. Michael Sheehe, New York

*L'Architecture d'Aujourd'hui*
ANONYMOUS
Letterhead
France (Boulogne)
Letter dated 1947
Letterpress

**PIERRE CHAREAU** (1883–1950)
Logo for letterhead
France (Paris), 1927
■ This architect, known for his magnificently austere interiors, used a surprisingly homey, hand-crafted logo on his professional letterhead.

**ÉMILE-JACQUES RUHLMANN**
(1869–1933)
Logo for letterhead
France (Paris), 1923
■ Ruhlman designed luxurious furnishings in a contemporary style. He achieved international acclaim after the 1925 *Exposition Internationale des Arts Décoratifs* in Paris.

**TONY GARNIER** (1867–1948)
Letterhead
France (Lyon)
Letter dated 1924
Letterpress
■ Garnier's architecture made innovative use of reinforced concrete. His letterhead uses ordinary typography on a stock that suited his approach to engineering: graph paper.

RÉDACTION : M. SEUPHOR — 5 RUE KLÉBER — VANVES-SEINE (FRANCE)

S/B                                    Paris den 10.Januar 1930.

Cher Ami,

       Hierdurch teile ich Ihnen mit, dass sich hier in Paris eine wichtige Gruppe von Kuenstlern, Gelehrten und Forschern aller Gebiete und aller Nationen gebildet hat, die sich geschlossen zum Prinzip einer strengen STRUKTUR bekennt, mich beauftragt hat eine Zeitschrift herauszugeben.

     Die erste Nummer soll baldigst erscheinen, und ich uebermittle Ihnen nur den Wunsch aller Anhaenger unserer Gruppe, indem ich Sie um Hilfe und Fuersprache bitte unsere weittragende und schwierige Aufgabe zu verwirklichen.

     Es handelt sich zu allererst darum, in einem oder in mehreren Saetzen, d.h. in kurzer,einfacher Form ohne Umschweife (wenn Sie wollen vom philosophischen oder sozialen Standpunkte au), die kuenstlerische Tendenz, die Sie vertreten und die Ihr Lebensziel ist, zu formulieren.

     Ich hoffe, dass Sie einverstanden sind an der Seite eines Mondrian, Vantongerloo, Stazewski, Léger, Ozenfant, Le Corbusier, Torrès Garcia, Brancusi, Léonce Rosenberg, Hans Arp, und vieler anderer zu stehen.

     Selbstverstaendlich ist unser aller Augenmerk auf die Basis "STRUKTUR" gerichtet und unter diesem Zeichen hat unsere Zeitschrift das Ziel, ein fuer allemal auf saemmtlichen Gebieten die Dinge klar zu legen.

     Wichtig:Ihre Mitarbeit ist, falls Sie einverstanden sind, vor dem 25.d.M. an obenstehende Adresse einzusenden und wenn moeglich 2 bis 3 Photographien Ihrer Werke beizufuegen, die eventl. reproduziert werden und, wenn Ihnen unsere Bewegung sympathisch und wichtig erscheint,uns frs.50.-franz. zu ueberweisen als Beitrag, den sich alle Mitglieder und Freunde unserer Gruppe oder unserer Zeitschrift auferlegt haben und welcher Anrecht auf ein Abonnement gibt.

     In der Erwartung, dass Sie uns Ihre Mitarbeit nicht versagen und uns vielleicht nuetzliche Ratschlaege erteilen koennen, zeichne ich fuer "CERCLE ET CARRE"

*Avec mon bon souvenir*
*et mes sentiments les plus*
*sympathiques*
*notre dévoué Seuphor*

*Cercle et Carré*
PIERRE DAURA (1896–1976)
Letterhead
France (Paris)
Letter dated 1930
Letterpress
■ The Spanish-born painter Pierre Daura created a pictographic logo for the journal *Cercle et Carré*, whose contributors included César Domela, Piet Mondrian, Kurt Schwitters, and Henryk Stazewski.

*Sonia*
SONIA DELAUNAY (1885–1979)
Letterhead
France (Paris)
Letterpress
■ Delaunay was an abstract painter and designer working in Paris. She was in contact with many members of the avant-garde during the 1920s, including Tzara, Breton, Soupault, and Aragon.
She designed theater costumes in collaboration with Tristan Tzara in 1920.

SONIA DELAUNAY
Letterhead
France (Paris), 1924
Letterpress

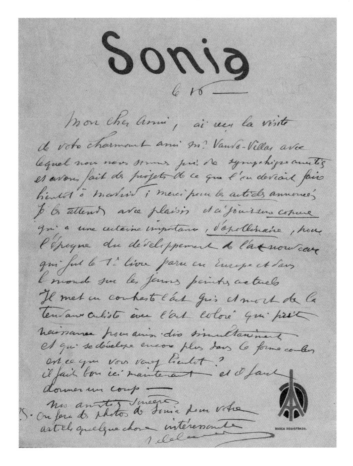

# POPULAR MODERNISM

Modern graphic design made its international passage through various routes, crossing boundaries marked by culture and geography, ideology and economics. The "New Typography" aimed to propel modernism into the mainstream by transforming the design of everyday media, from ads and magazines to books, logos, and stationery. With its austere, therapeutic concepts of geometric reduction and objective communication—what MOHOLY-NAGY called the "hygiene of the optical"—avant-garde typography in the 1920s was driven by a spirit of social critique. Although members of the Bauhaus, De Stijl, and the *ring* desired to reach a broad public, they sought to reform—not satisfy—popular taste. ■ Modernist ideas nonetheless journeyed to other cultural spheres, where they were freely interpreted by illustrators, lettering artists, printers, and designers working for a diverse range of clients. New styles travelled beyond the inner circle of vanguard producers via the same network of exhibitions, lectures, and publications that fueled the movements' most rigid theorists. ■ Ideas developed in the context of avant-garde typography appeared in a more popular form on numerous letterhead designs in the 1920s and 30s, which used asymmetrical compositions and surprising shifts of scale in combination with colorful illustrations and decorative typefaces. ■ The assimilation of avant-garde theory can be seen in the trade magazines of the period. ANTHONY BELL, writing in Britain in 1939, argued that while traditional businesses may wish to "echo their pedigree with copperplate frolics and lush die-stamping" on their letterheads, modern firms needed a more modern look: "Industry is not all hats and York hams. There is steel and cement. And there are cars and wireless sets and plastic goods. And frigidaires and fire extinguishers." Bell offered modernism not as an absolute philosophical imperative but as suitable attire for promoting certain kinds of content. He suggested that  modern styles be used selectively, in the appropriate situations.

BIBLIOGRAPHY
Anthony W. Bell, "Take a Letter...A Random Note or Two on Letterhead Design," *Art and Industry* 27, 169 (October: 1939): 148–155.

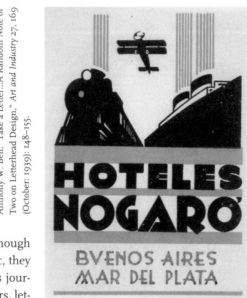

*Hoteles Nogaro*
ANONYMOUS
Luggage label
Argentina (Buenos Aires), 1930s
Letterpress
Collection Cooper-Hewitt, National Design Museum, Smithsonian Institution, Sarah Cooper Hewitt Fund
■ The international aspirations of the avant-garde found popular expression in the global tourist industry, where the steamship, airplane, and railway car were not merely symbols of modernity but the means of passage.

*Hamburg-Amerika Linie*
ANONYMOUS
Letterhead
Germany (Munich), 1930s
Offset lithograph
Collection W. Michael Sheehe, New York

*Nord Deutscher Lloyd Bremen*
ANONYMOUS
Letterhead
Germany (Bremen), 1930s
Letterpress
Collection W. Michael Sheehe, New York

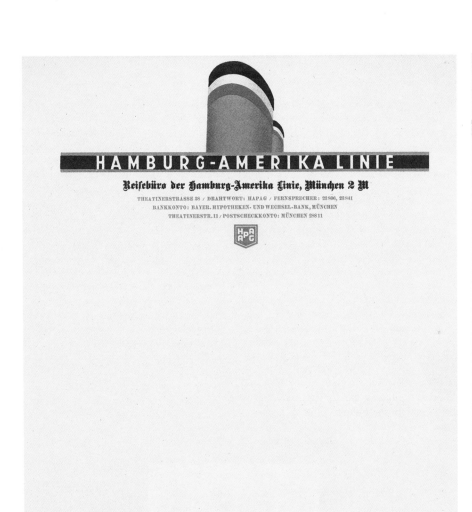

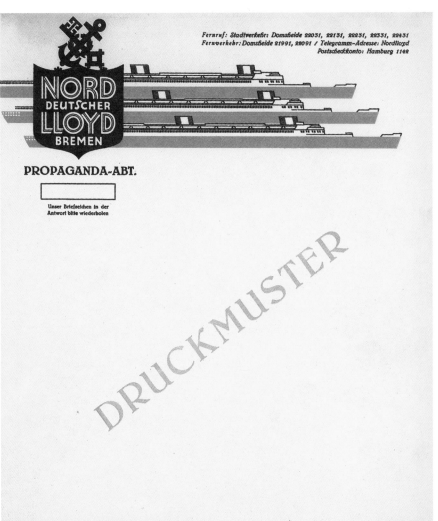

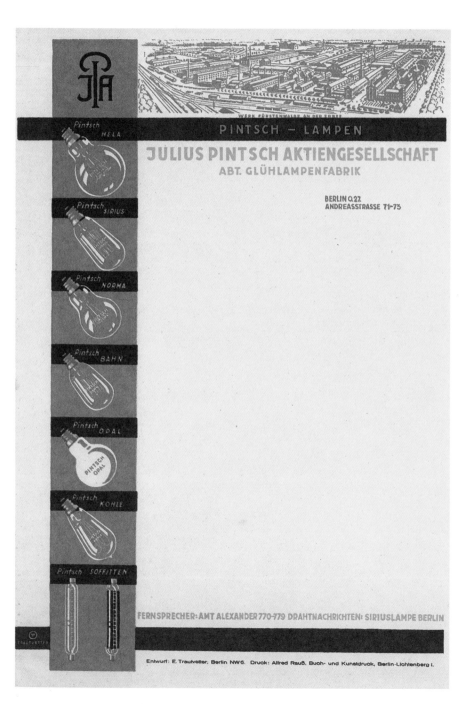

*Julius Pintsch Aktiengesellschaft*
E. TRAUTVETTER
Letterhead
Germany (Berlin), 1930s
Offset lithograph
Collection W. Michael Sheehe, New York
■ The illustrations recall the poster style
made famous by Lucian Bernhard
and Ludwig Hohlwein in the 1910s.
The transparency of the light bulbs has
been cleverly rendered. The factory, a
mainstay image from the tradition of the
vernacular letterhead, achieves the scale
of a landscape.

*Margarete Steiff*
GRAPHIA / MUNICH
Letterhead
Germany (Giengen)
Letter dated 1932
Offset lithograph
Collection W. Michael Sheehe, New York
■ Photographs and diagrams of toys
share the margin.

*Drukkerij Levisson*
ANONYMOUS
Letterhead
Netherlands (The Hague)
Letter dated 1938
Letterpress

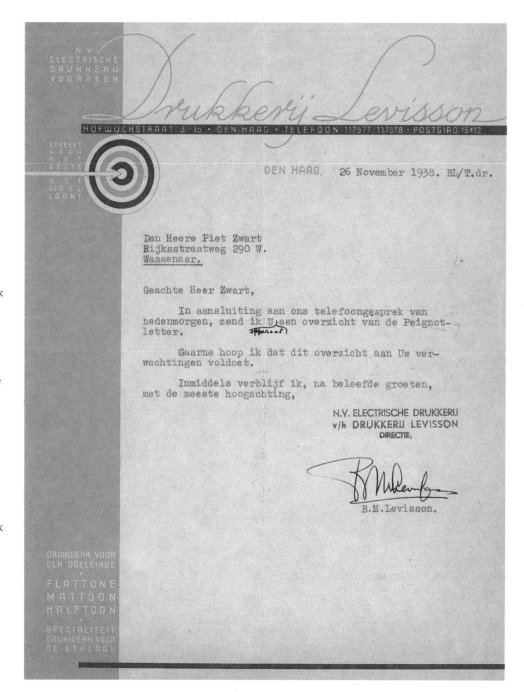

*"Ounces or Tons," Teal Air Cargo*
ANONYMOUS
Shipping label
England, 1930s
Letterpress
Collection Cooper-Hewitt, National Design
Museum, Smithsonian Institution, Sarah
Cooper-Hewitt Fund

*Imperial Airways, Transatlantic Air Mail,
Britain/America*
E. McKNIGHT KAUFFER (1890–1954)
Envelope
England (London), between 1914 and 1939
Letterpress
Collection Cooper-Hewitt, National
Design Museum, Smithsonian Institution
■ Born in Montana, Edward McKnight
Kauffer moved to England in 1914, where
he applied Cubist-inspired motifs to
posters, advertisements, stationery, and
other projects. He returned to the U.S.
at the beginning of World War II. He had
a broad impact on design in Great Britain,
as seen in the anonymous design above
for a shipping label.

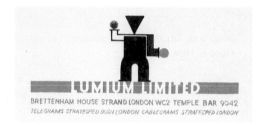

*Lumium Limited*

E. McKNIGHT KAUFFER

Design for letterhead (top)
Gouache, metallic paint, and graphite
Printer's proofs (right)
England (London), 1935
Letterpress
Collection Cooper-Hewitt, National
Design Museum, Smithsonian Institution,
Gift of Mrs. E. McKnight Kauffer
■ These preliminary proposals and
printer's proofs show the evolution of one
of Kauffer's letterhead designs. The
humorously abstract, machine-like figure
recalls the work of Lucian Bernhard and
other popular modernists of the period.
In his pencilled note to the printer,
Kauffer requests that his initials be added
to the final printed version. The initials
were included in the next proof.

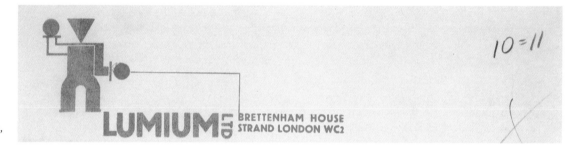

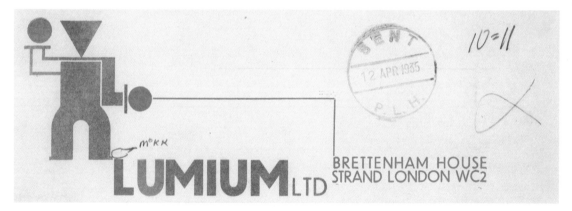

# MODERNISM IN AMERICA

The styles and theories of the avant-garde travelled to the U.S. across various routes. During the late 1920s, the American designer DOUGLAS C. McMURTRIE carried on a written correspondence with many members of the avant-garde, including WILLY BAUMEISTER, HERBERT BAYER, KURT SCHWITTERS, TRISTAN TZARA, and EL LISSITZKY. This correspondence culminated in the publication of McMURTRIE's *Modern Typography and Layout* in 1929. McMURTRIE tapped into the network of avant-garde communication, assembling his book in much the way JAN TSCHICHOLD had compiled *Die Neue Typographie*: he wrote to designers across Europe and requested samples of their work for reproduction. ■ Designers in the U.S. gained increasing access to information about the avant-garde during the 1930s, when many artists and intellectuals emigrated from Germany. LASZLO MOHOLY-NAGY, WALTER GROPIUS, HERBERT BAYER, and LADISLAV SUTNAR moved to America, where they practiced and promoted modernist design methodologies. Their progressive ideas were met with excitement by a small community of designers in the U.S., including ALVIN LUSTIG and LESTER BEALL, who interpreted concepts from Dada, Futurism, Constructivism, and Surrealism in the context of American culture. ■ This commercial vanguard helped lay the foundation for the modern profession of graphic design in the U.S., which dramatically expanded during the post-war period and profoundly changed the appearance and function of American media. Principles of abstract composition, symbolic forms, and expressive typography were applied to books, magazines, and corporate identity. A sense of humor enlivens the work of many American designers from the 1940s and 50s, who rejected the programmatic aspects of the "New Typography" in favor of a permissive and individualistic sensibility.

BIBLIOGRAPHY

McMurtrie, Douglas C. *Modern Typography and Layout*. Chicago: Eyncourt Press, 1929.

Wild, Lorraine. "Europeans in America." *Graphic Design in America: A Visual Language History*. Ed. Mildred Friedman. Minneapolis: Walker Art Center, 1989. 152-169.

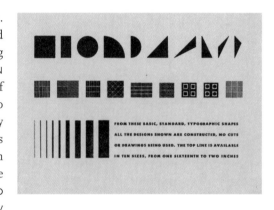

*Basic, Standard, Typographic Shapes*
ALVIN LUSTIG (1915–1955)
Promotional piece
U.S. (Los Angeles), 1940s
Letterpress
■ Lustig promoted his services to prospective clients with this showing of ornaments available in the printer's type case. Lustig used a minimal vocabulary to invent surprising symbols and abstract illustrations.

*Ralph Samuels Photography*
ALVIN LUSTIG
Letterhead
U.S. (Los Angeles), mid-1940s
Letterpress
■ Lustig demonstrated his sense of humor in this design, constructing the image of a camera from simple geometric elements.

*Stanley P. Murphy Company*
ALVIN LUSTIG
Letterhead
U.S. (Santa Monica), 1940s
Letterpress
■ The text of this letter instructs Lustig's client how to properly use his new stationery. The strong indent and rigid left-hand margin give the typed page a strong, distinctive composition.

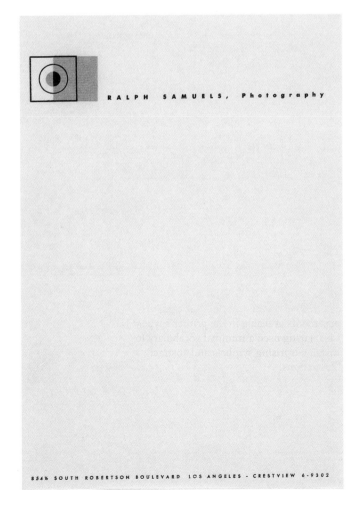

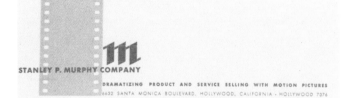

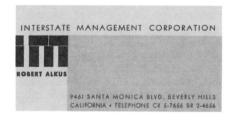

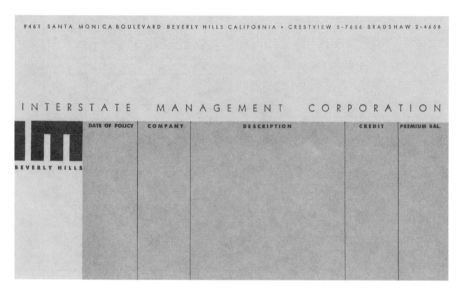

*Interstate Management Corporation*
ALVIN LUSTIG
Business card and invoice
U.S. (Beverly Hills), 1940s
Letterpress
■ The letters "I" and "M" are constructed out of rectilinear pieces of metal used in printing. A similar technique was employed earlier in the century by Wijdeveld and Zwart. In this ambitiously printed stationery, large fields of flat color divide the surface of each piece into painterly zones.

*upa*
ALVIN LUSTIG
Invoice
U.S. (New York), 1947
Letterpress
■ Lustig created two stationery programs
for United Productions of America. The
first design employs a gestural logo that
reflects Lustig's interest in biomorphic
surrealism. Note the strong placement of
the typed text on the page, and Lustig's
fee for designing the stationery.

*upa*
ALVIN LUSTIG
Letterhead
U.S. (New York), 1949
Letterpress
■ In contrast with the precisely ordered
fields for information that Tschichold had
advocated in *The New Typography*, Lustig's
design leaves the space of the page largely
open. It is punctuated with type and
symbols in a discreet but painterly and
idiosyncratic manner.

**LB**

May 11, 1951

Mr. Alvin Lustig
9126 Sunset Blvd.
Los Angeles 56, Calif.

Dear Mr. Lustig:

Mr. Harry Jones, President of the Advertising Creative Circle,
London, has asked me to collect a series of advertisements re-
flecting the best in American Advertising Design for exhibition
in connection with the International Advertising Conference which
is to be held in Lond
particularly interest

1.  Examples of
    standingly su
    Advertising.

2.  Examples of
    Advertising.

I would appreciate it
of your work such as
All work that I receiv
mittee in London. So
of the Exhibition that
not later than May 18
and name of client on

*lester beall 580 fifth avenue new york 19 plaza 7-5250*

**S**

Sutnar—office

December 5, 1955

Mrs. Elaine Lustig
152 East 58th Street
New York, New York

Dear Mrs. Lustig:

Permit me to join your many friends in extending my deepest sympathy
on the loss of Alvin.

Sincerely,

*Ladislav Sutnar*

Ladislav Sutnar                                              ls/jd

*Sutnar-office—307 East 37 St—New York 16, NY—MU 6-1784*

*Will Burtin*

Visual research and design

Suite 1842-43
11 West 42nd Street, New York 18, N.Y.
Phone LOngacre 4-7255

Mr. Alvin Lustig,                                    August 3, 1950
9126 Sunset Boulevard,
Los Angeles 26, California.

Dear Alvin:

Thanks for your letter; I have not seen your new chairs
yet but hope they will be successful.

May I ask you a favor? I misplaced the address of the
Society of Contemporary Designers. As I do not want to
delay my entries any longer, I would appreciate your
forwarding the package to the Society. I hope it is not
too much trouble.

We are fine here, and quite busy. I will not be able to take
a vacation this summer, but spend the weekends at my place
on Fire Island.

My best to you and Elaine, also from Hilda.

Cordially yours,

*Will*

Will Burtin.

George Nelson

*343 Lexington Avenue, New York 16, N.Y.*

September 28, 1948

Dear Alvin:

I have just received the news of
your engagement. I wish I could have been pre-
sent at the party Sunday. Maybe I'll get out
in time for the wedding. In the meantime, all
good wishes to you both.

Best,

GN:ML

*Rachmaninoff Fund*
RICHARD HAAS (b. 1898)
Letterhead
U.S. (New York), c. 1945
Letterpress
Collection Cooper-Hewitt, National Design
Museum, Smithsonian Institution,
Gift of James Fraser and Caitlin James
■ With a sense of humor typical of American
graphic design, this letterhead uses
typographic rules not only as abstract structure
but also as symbolic illustration.

*Pierre Matisse Gallery*
RICHARD HAAS
Letterhead
U.S. (New York), c. 1946–47
Letterpress
Collection Cooper-Hewitt, National Design
Museum, Smithsonian Institution,
Gift of James Fraser and Caitlin James
■ The typography occupies the entire page,
serving as background for the typed letter.

LESTER BEALL (1903–1969)
Letterhead
U.S. (New York)
Letter dated 1951
Letterpress

LADISLAV SUTNAR (1897–1976)
Letterhead
U.S. (New York)
Letter dated 1955
Letterpress
■ Both Lester Beall and Ladislav Sutnar
chose to represent themselves with a large
initial positioned in the upper-right corner
of the page. The effect is direct, forceful,
and free of the theoretical overtones
associated with the "New Typography"
of the 1920s.

WILL BURTIN (1908–1972)
Letterhead
U.S. (New York)
Letter dated 1950
Letterpress
■ Burtin described his business as
"visual research and design."

GEORGE NELSON (1908–1986)
Letterhead
U.S. (New York)
Letter dated 1948
Letterpress

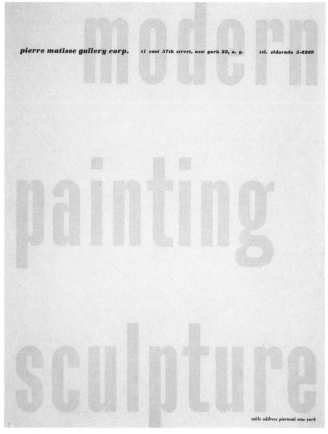

## PHOTO CREDITS

# INDEX

*Book designer*
ELLEN LUPTON

*Editor*
MARK LAMSTER

*Typefaces*

SCALA
Designed by Martin Majoor, 1991

COPPERPLATE GOTHIC
Designed by Frederic W. Goudy, 1905

BUREAU GROTESQUE
Designed by David Berlow, 1989